SECRET
BRIGHTON

Kevin Newman

AMBERLEY

For Carol and Fergie Newman with love. They are two Brightonians who have loved every aspect of living in Brighton for over half a century.
They get a bit stroppy when they can't park their car during Pride, mind.

First published 2016

Amberley Publishing
The Hill, Stroud
Gloucestershire, GL5 4EP

www.amberley-books.com

Copyright © Kevin Newman, 2016

All the illustrations are the authors', except where acknowledged.

The right of Kevin Newman to be identified as the Author of this work has been asserted in accordance with the Copyrights, Designs and Patents Act 1988.

ISBN 978 1 4456 6150 6 (print)
ISBN 978 1 4456 6151 3 (ebook)

British Library Cataloguing in Publication Data.
A catalogue record for this book is available from the British Library.

Origination by Amberley Publishing.
Printed in Great Britain.

Contents

Introduction 4

1 Land, Sea and Air 11

2 Hell and High Water 32

3 Fun and Games 44

4 Sickness and Health 48

5 Cash and Carry 52

6 Sticks and Stones 62

7 Fish and Chips 71

8 Chew a Pickle 75

9 Slap and Tickle 78

10 Words and Pictures 86

Acknowledgements 95

About the Author 95

Selective Further Reading 96

All-Inclusive History Tours of Brighton 96

Introduction

Secrets are generally things held by individuals, are little known and are things that people don't want known. This might seem a bizarre topic for a book on Brighton, one of the UK's seemingly best-known places and a location visited by so many people in such large numbers every year – over 10 million per annum still. However, scratch beneath the surface and Brighton can be a dark, brooding, secretive and mysterious place. Towns at the end of the line always are; there is something exciting about a place where 180 degrees of your options for movement are wet, increasingly deep, dark and dangerous.

Brighton is also not just a place on the edge, it has sometimes nearly been pushed over the edge. Invaded by Saxons, Vikings and Normans, each of whom left not just their place names but a bloody footprint, Brighton (or Brighthelmstone as it was until 1810) was nearly wiped off the map by the French, economic downturns and most of all the encroaching waves. The sea led to Brighthelmstone being nearly abandoned with 113 buildings washed away in 1665 and dozens more in the early eighteenth century. Daniel Defoe, who knew a few things about waterside locations, questioned whether the investment needed to pay for coastal defences to save the town was worth spending.

It was then saved by the same waves, this time however as a substance for the rich to be dunked under, to swim in, promenade beside and even to drink with milk. Dr Richard Russell's decision to treat his wealthiest patients with his sea cures in his hydro at his nearest low-lying established coastal settlement accelerated the town's recovery but also

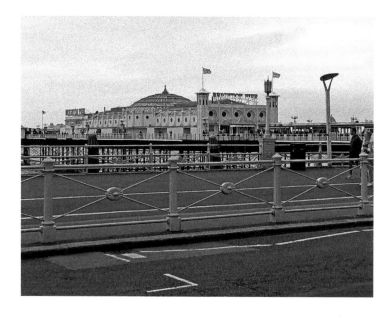

Brighton's famous pier today.

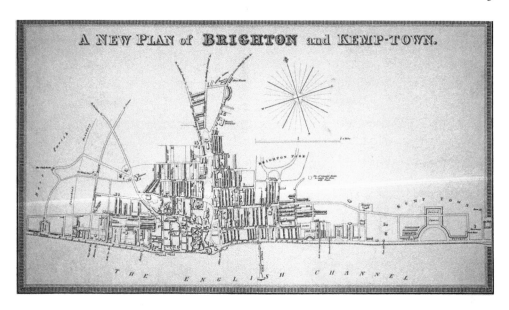

An 1820s' map of the plans for Brighton and Kemp Town, showing the rapid pace of growth during the period when George IV used the town as his summer home. (Picture courtesy of Royal Pavilion and Museums, Brighton and Hove)

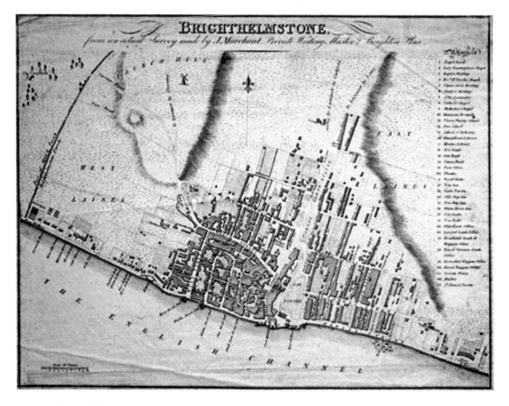

A map of Brighthelmstone, *c.* 1800s. (Picture courtesy of Royal Pavilion and Museums, Brighton and Hove)

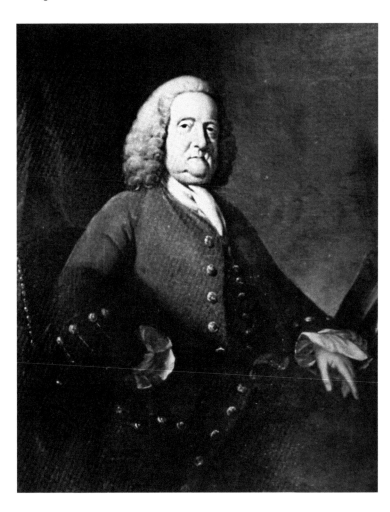

Left: Dr Richard Russell.

Below: Dr Richard Russell's house and surgery or hydro, the spiritual heart of seaside resorts everywhere.

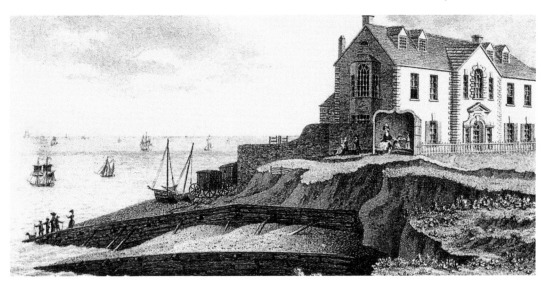

the idea of spending time by the seaside. The fact that the first visitors were extensively wealthy meant that the secrets were linked with court intrigues and affairs. The secrecy that wealth could buy meant that from its earliest days Brighton was built as a place of gossip, scandal and intrigue. Brighton became fashionable as people copied the Prince Regent, himself escaping the watchful eyes of court so that he could indulge in whatever secretive and scandalous behaviour or relationships he chose. He chose, of course, to engage in his on-off secret marriage with Mrs Fitzherbert away from his father's gaze. So those who copied the prince by moving to Brighton were moving, or at least visiting, based on a pack of secrets.

As the town mushroomed in size to support the visiting wealthy and landed classes, a series of slums, communities and areas developed that would all have their own distinct character and their own traditions and secrets. By the time the royals left Brighton in the 1840s, the working classes had descended upon the town via the new railway, bringing their ways with them, and Brighton's railway communities also created their own worlds across new areas such as North Laine, as it would be known again by the 1970s.

Brighton has always had an air of the shabby, the suspect, the criminal and the underworld. As local crime author Peter James said in an interview I undertook with him for the 'Brilliant Brighton' series I write for the *Argus*:

Storyteller of all things Brighton, including the city's dark and secretive side, Peter James..

Brighton is a hip, beautiful seaside city, but it has a long history of darkness – right back to its roots as a smugglers village! In Regency days it gained a reputation both as a fashionable bathing resort, but in 1841 when the London–Brighton railway line opened, criminals flooded down from London, finding rich pickings and a much nicer environment than their city! They brought cock-fighting, prostitution, pickpockets, muggers, smugglers, burglars, and gangs. Simultaneously, with the railway enabling quick access from London, many wealthy Londoners brought their mistresses down here and it became known as a place for 'dirty weekends'.

Peter also continued to explain why he thought the city still had a scary air about it today:

Three consecutive past Chief Constables of Sussex Police have all told me that Brighton is the favoured place in the UK for first-division criminals to live in. The reasons are: Firstly it has a lot of escape routes, very important to all criminals; it has the Channel ports, Eurotunnel, and Gatwick Airport just 25 minutes away. London is only 50 minutes by train; it has a major seaport on either side – Shoreham and Newhaven, perfect for importing drugs and exporting stolen cars, antiques and cash; it has the largest number of antique shops in the UK – perfect for laundering stolen goods and cash; for many recent years it held the title the Tourist Board would probably not like me mentioning: 'Injecting Drug Death Capital of England'; it has a wealthy young population combined with the largest gay community in the UK, providing a big market for recreational drugs; it has two universities, so a big drug-taking student community, a huge number of nightclubs and a large transient population.

All of this means that the wonderful Keith Waterhouse line, 'Brighton has the air of a town that is perpetually helping the police with their enquiries', is both funny and true.

Once well-known features of Brighton society also have become forgotten over the years and I try to feature here some of the aspects of Brighton life that were once common knowledge. For example, the Hilton Brighton Metropole's staff and I are still trying to locate the hotel's once-famous Turkish baths, its second huge staircase and its porte cochère (or storm entrance) in the absence of copies of early plans of the hotel's layout. We did, however, locate Victorian stained-glass windows for watching storms through and Alfred Waterhouse's fantastic gold-leaf ceiling, which has been hidden in Brighton's biggest hotel for over fifty years from the public.

Finally, I've gone one step further and have stretched the definition of 'secret' in this book by including things that are so unknown, even by Brightonian standards, that they might as well be a secret. One is a human interest story that is also so emotive that I feel that it deserves to be heard. The sad tale of Frederick Wesche (which ultimately has a happy ending so don't worry), deserves knowing by all Brightonians as it tells of war's effect on proud Brightonians like Frederick. This story occured just over a century ago.

So, there are many features that make Brighton secretive, sometimes sinister and certainly a place of intrigue and interest. In this book I will try and cover these, but I also hope to cover what has been long forgotten. This book tackles all of these many facets of Brighton in a thematic way. We start off with the elements.

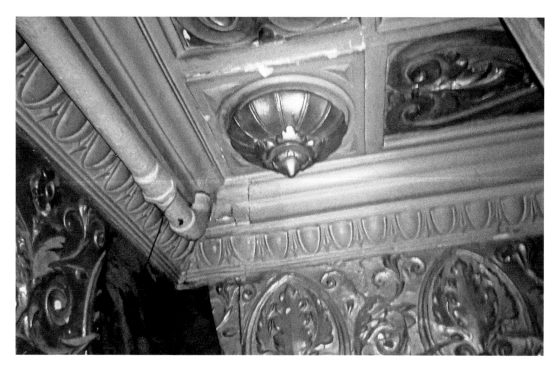

The hidden ceiling at the Metropole.

The hidden stained-glass window from the outside..

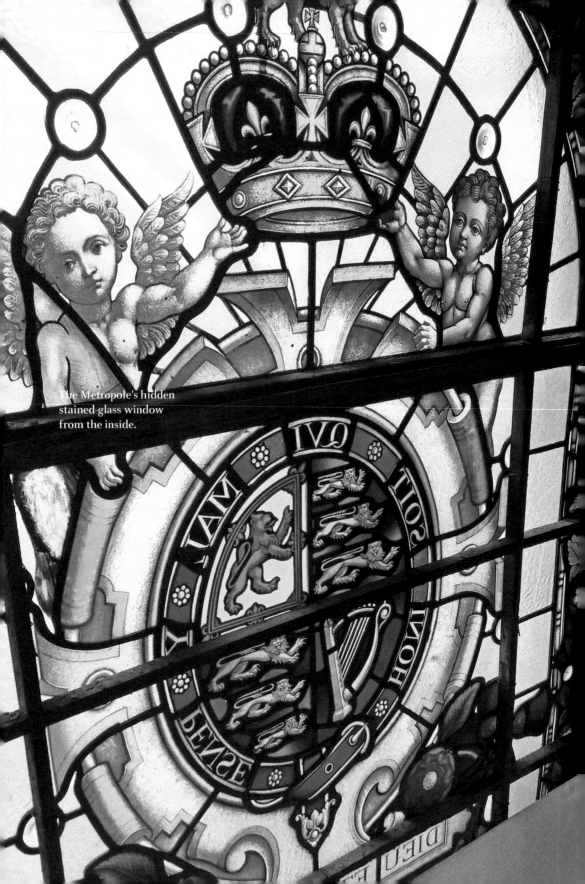

The Metropole's hidden
stained-glass window
from the inside.

1. Land, Sea and Air

Land

Starting with the basics, many people don't know that despite being on the south coast, Brighton has spread out not only northerly, westerly and easterly but southerly since its earliest days. Also little known is that its southerly fishing community, which was based on the beach and you can see in the earliest picture of Brighthelmstone (1514), was washed away by the 1700s due to erosion and horrendous storms. If you look at an early drawing of Dr Richard Russell's house, pictured on page 6, we notice it was precariously perched on crumbling chalk cliffs, whereas today the Royal Albion Hotel that has replaced it is safely inland behind a dual carriageway, promenade, esplanade and a wide shingle beach. Brighton was being eroded northwards, its chalk cliffs offering little protection from the encroaching tides, but the building of the coastal King's Road (paid for by George IV, hence the name), sturdy groynes and tidal deposition in between these, means Brighton has since moved southwards further out over the sea than the old fishing dwellings beneath the cliffs ever did. Should you believe in the spiritual, these hardy fishing folk, who would have lost their lives in droves in the storms of the eighteenth century, don't inhabit the area where the sea now is, but instead our sewer tunnels and space under our coastal road, built outwards over where the sea once lapped.

We forget that where the Madeira Terraces now stand, the cliffs underneath, encased in cement and awaiting a much-needed restoration at time of writing, were once the shoreline. We also forget that these chalk cliffs, always referred to on early maps (the area

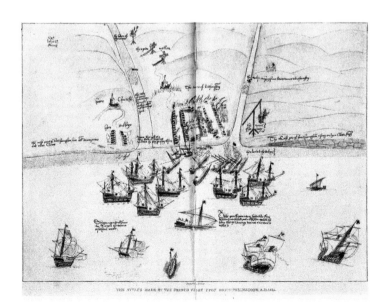

The first ever picture of Brighton, or Brighthelmstone as it was called in 1514.

The Royal Albion Hotel, once the sea-edge location of Russell's hydro, today safely inland.

where the Metropole is today was once 'West Laine Cliff Butts' for example) have been not only encased under concrete and tarmac, but are part of the same cliffs that make up the cliffs at Peacehaven, the Seven Sisters and indeed even Beachy Head.

Brighton has lost not just its beach-dwelling fishing village, but also a village high up on the Downs. Balsdean, near Woodingdean, was a Saxon village that survived the Vikings and the Normans but was evacuated in the Second World War so that the artillery could use its rural buildings as targets in preparation for D-Day. Balsdean once had a manor house, cricket pitch, barns, lunatic asylum and even a chapel. It also had pluck. It reputedly was where Sussex yeomen stood their ground and stopped invading Frenchmen reaching Lewes in 1377 after the destruction of Rottingdean.

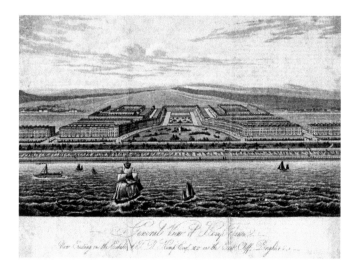

Home to not just one but two 'secret' tunnels, one of which inspired *Alice's Adventures In Wonderland*. (Picture courtesy of Brighton Print Collectors)

Heading under the land, Brighton has numerous tunnels – Kemp Town's is one of the most secretive and was believed to be a smugglers' tunnel, as is one that led towards the Druid's Head. The Kemp Town tunnel, which has since collapsed and been filled in, gained its reputation partly due to the publicity campaign by Magnus Volk when his electric railway was extended. Volk was allowed to extend his original railway as he was forced to move the westwards end station eastwards for a planned swimming pool that never was built. The extension was also partially allowed as recompense for the treatment Volks received by the council over his 'Daddy Long Legs', where his seagoing railway was forced to be rerouted around new groynes, effectively meaning that it had to close. Black Rock, before the days of the construction of the mammoth marina, was a wild and windswept place and it was easy for Volks to claim the tunnel had been a smugglers' route. The truth was far less exciting. In the 1820s, the tunnel was needed for the building of Kemp Town. Its supremely wealthy residents were far from the sort that would countenance illicit imports to the country, but the construction of the estate meant that large amounts of building materials had to be brought by sea. In the days before the railways, much of Brighton's resources were brought into the town across the beach. Kemp Town even had its own temporary marina as the estate was being built, such a huge building project it was. It was big enough to bankrupt its financier, Thomas Kemp MP, who ended up dying in poverty in France. The Pavilion was also rumoured to have an underground tunnel to everywhere, including the Druid's Head and the Market Inn, then called the Three Chimneys after its ownership by the Pavilion's head chimneysweep.

Not surprisingly, considering the Prince Regent's drinking habits, there is even rumoured to be a tunnel from the Pavilion to the shop that sold booze on the corner of Church Street and New Road! Roedean has a tunnel built in 1910 to the sea. Southern Water have built a tunnel 5 kilometres long and 6 metres wide under the whole of Brighton and Hove, following the line of the coast but it is not a secret; instead it exists to prevent storm water entering the sea straight from Brighton's drains without being treated first to make it nice and clean. A more magical tunnel in Brighton must be the small one in Sussex Square that goes to the sea. It is said to have inspired Lewis Carroll

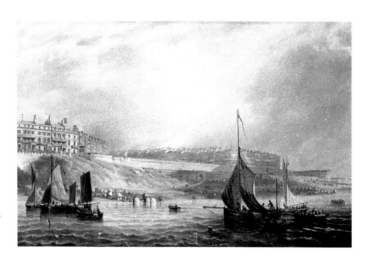

Kemp Town. (Picture courtesy of Royal Pavilion and Museums, Brighton and Hove)

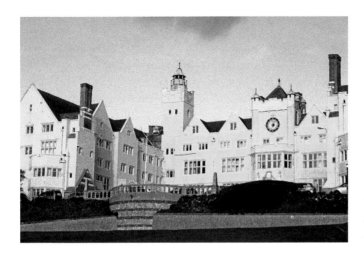

Roedean School for girls
also has another 'secret'
tunnel built in 1910 to
the sea.

when he saw a rabbit disappear down it. *Alice's Adventures in Wonderland* therefore
owes something to our waterside wonderland of Brighton! The Daddy Long Legs
mentioned earlier, which travelled across the land at low tide (and also through the sea
at high tide) is also said to have inspired H. G. Wells to create the aliens in *The War Of
The Worlds* (1898).

Moving from below the earth to 400 feet above it, the land high above Brighton is
where the earliest Brightonians were buried. This is in a causewayed enclosure, which was
some sort of camp for feasting and rituals, but not, it seems, a military defence. The camp
is over 1,000 years older than Stonehenge, dating from the Neolithic part of the Stone
Age (*c.* 4000 BC–2500 BC). The remains of a young woman and her newborn child told us
much about this era, but also provided us with questions we may perhaps never answer,
such as why were they buried, did they die of natural causes and why were they buried
with animal bones and other rubbish? Was this a punishment for a young mother back
at a time when children were lucky to make it into adulthood? The fact the mother was
buried with an ox bone, two fossil sea urchins (called shepherds' crowns) and two chalk
'pendants' with holes drilled in them perhaps suggests otherwise – these were probably
good-luck talismans for the afterlife. The remains are at Brighton Museum should you
wish to make your own mind up.

In the land high above Brighton is St Nicholas's Church. Within its graveyard many
eminent Brightonians and Brighthelmstonians are buried. Sake Dean Mahomed, who
brought the term 'shampooing' to the town (and the English language, although it didn't
mean cleaning your hair at the time), was buried in 1851 at the age of 102, reputedly on
the site of Brighton's plague pit. His famous baths, which treated royalty, are now at
the location of Queens Hotel. If St Nicholas's was a plague cemetery, it may explain the
answer to the long-forgotten secret of why Brighton's original parish church (and oldest
building) was built so far away from the town. One theory is that a separate community
existed high up from the farmers and fishermen on the hill. Another secret the church
has never revealed is why the font inside dates back to the early medieval era but the
oldest parts of the building only go back to the later medieval era. There was a church

in Brighthelmstone in the Domesday Book in 1086 but it isn't clear if it is St Nick's. The church would more likely to have been at the Knab, the small peak in the Lanes, and would have been named by the Vikings, where the Pump House pub is today. Like Worthing, the town may well have had a chapel in the fishing village on the beach, washed away by the sea by the 1700s. St Nicholas's survived not only the French attack of 1514 but also a German fighter aircraft crashing into the graveyard in a Second World War attack in 1944 where both pilots died. One of the pilots, who ended up hanging from a branch of a tree, had been decorated with the Iron Cross and he is now buried in Bear Road cemetery.

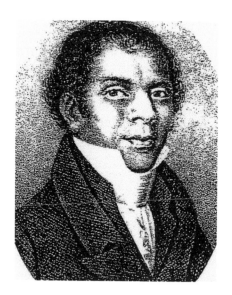

Sake Dean Mahomed, who brought the term 'shampooing' to the English language, is reputedly buried on the site of Brighton's plague pit.

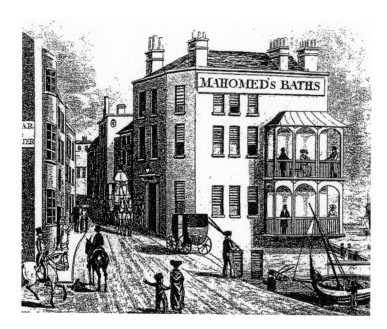

Mahomed's baths was the bathplace of royalty. Today it is the location of Queens Hotel.

It is little known that the Vikings controlled the land around Sussex in the time of King Alfred, but even less known that this happened again a second time. This took place during their successful invasion that led to Sweyn Forkbeard being proclaimed King of England on Christmas Day 1013. These invasions mean that we have not only the Knab (Brighton Place today), but the Steine, itself a Scandinavian word for 'stones' or 'stoney ground'. Hove is also a Viking word, which explains its atypicality among a sea of Saxon names ending in '*ham*', '*ber*', '*ing*' or '*ton*'. The Vikings under Sweyn Forkbeard were able to conquer England partially due to the treachery of a Sussex lord, who handed over much of Aethelred the Unready's naval fleet to them. The French also took over Sussex almost exactly 200 years later in 1216, due to the ineptness of King John, who, not content to lose all his French territory, nearly lost his English lands too. Few people know of the 1216/17 invasion of England by Prince (later King) Louis of France and few history teachers even teach it, but Sussex was well and truly conquered by the French prince with both Chichester and Bramber castles under his control. Only John's death, a successful campaign by one of John's top knights and payment of a large sum of money led to the French invader not copying the success of his Norman predecessor 150 years before.

Land and Sea

The Sea Life Centre is a wonderful mix of water and land that was built under the ground in Brighton. Built on the entry gates and road to the old Chain Pier, the Sea Life Centre (as it has been since 1991) started life as the Aquarium. It opened in August 1872 and was redesigned in the late 1920s. It is the work of Brighton's aptly named architect, Eugenius Birch, who

The interior of the Aquarium. (Picture courtesy of Jackie Marsh-Hobbs, Royal Pavilion and Museums, Brighton and Hove)

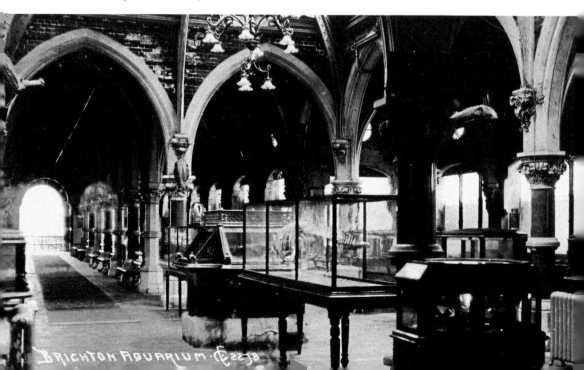

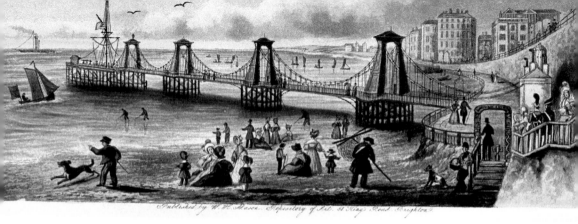

The Chain Pier was Brighton's first pier and the world's first pleasure pier. (Picture courtesy of Brighton Print Collectors)

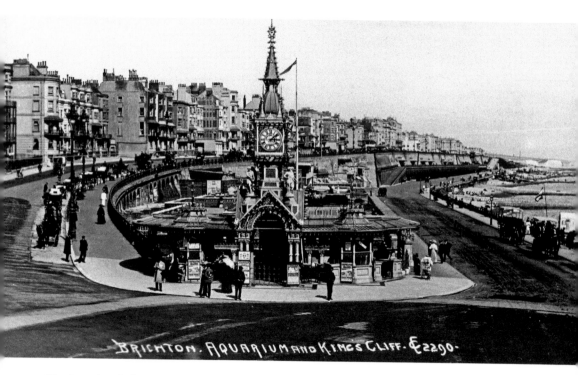

The Aquarium before 1927. (Picture courtesy of Jackie Marsh-Hobbs, Royal Pavilion and Museums, Brighton and Hove)

DID YOU KNOW?

You can also see a reminder of Brighton's smuggling past should you journey to the grave of Daniel Skayles, a smuggler who is buried in All Saints' Church graveyard in Patcham. His profession, his tombstone tells us, got him 'unfortunately shot' in 1796.

also built Hastings Pier and the West Pier. The Aquarium, as it was, is linked to the Chain Pier in that it was built on the site of that pier's tollhouse and slip road. It is the world's oldest operating aquarium and was inspired by other similar aquariums in Boulogne and elsewhere on the Continent. It is little known that it was the first recreational aquarium anywhere in the country and had the world's biggest tank of water in it at the time. Costing £133,000 to build (£5.5 million today), it was hailed as a fantastic piece of architecture when opened, especially as it was cleverly constructed under the ground. The original design was meant to have towers and turrets, but these weren't built as it was felt they'd spoil sea views. This is why it is built into the cliff – the building wasn't allowed to be above the level of Marine Parade above. Still, today in our century it can provide amazing views of sea life, some of which is scarily lethal. In 2006, the Sea Life Centre became the first UK aquarium to house sea serpents, each with enough poison to kill three people with one bite! Brighton's fans of watery worlds have even tried to enjoy a much-sought-after view, that of the famous Loch Ness Monster. David James, MP for Kemp Town back in the 1960s, was the founder of the Bureau for the investigation of the Loch Ness Monster.

One of the views in Brighton that is hidden, but by a high bank of shingle, is that of Brighton's naturist beach in Brighton. Brighton was the first place in the country to open a beach for those who 'dare to bare' in 1979, causing much disgruntlement from the more prudish elements in society. Today we even celebrate the naked bike ride event in Brighton so naturists are now on the move as well as on the shingle near Black Rock. Brighton not only has groins of the human type on display, but also a range of the beach-defence type as well, the first being constructed back in 1724. Some of Brighton's groynes are named after beaches and the rest mostly after hotels, the exception being 'Athina' after the *Athina B* shipwreck in 1980. Brighton's beaches are even named after these groynes. This means today that our beach names include: Boundary, Norfolk, Bedford, Metropole, Grand, Old Ship, Centre, King's, Albion, Palace Pier, Aquarium, Volks, Paston, Banjo, Crescent, Duke's, Black Rock and Cliff. Perhaps our renamed large 1980s' hotel, the Jury's Inn Waterfront, should apply to have Centre Beach renamed after it to add to the pattern? 'Jury's Beach' would be better though than 'Waterfront Beach' as of course, you'd hope all beaches are on the waterfront!

It might seem strange to discuss UFOs in a section of the book on land and sea, but Brighton is apparently the second most popular place in the country to spot them, according to local paper the *Argus*. However, by UFOs, we mean Unidentified *Floating* Objects. The Barefoot Wine Beach Rescue Project, which works with national environment charity Surfers Against Sewage (SAS), has uncovered an exceptionally high level of alien artefacts on Brighton's beaches. Many of the items washed up are indeed mysterious and unidentifiable, but items that have been found include thousands of identical blue balls, blue plastic stoppers and multicoloured nylon pellets known as 'mermaid's tears'.

As we move from land to sea, Brighton has some surprising places on land that used to, or still do contain water. There was also once Wick Pond, which is now in Lansdowne Place, where Victorian skaters used to enjoy ice-skating in the 'mini-ice-age' of the 1840s, followed by a glass of hot spiced ale at the Wick Inn. Another hidden watery wonder is Waterhall, north-west of Patcham, once a potential venue for the Albion and now an underground reservoir as well as a sports ground.

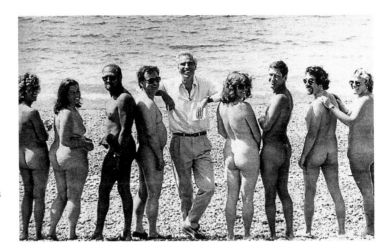

Nudists on Brighton's Cliff Beach – not believed to be named after Cliff Richard.

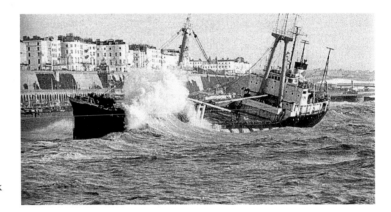

The *Athina B*, Brighton's last significant shipwreck in 1980.

Sea

An old belief was that one of the first Brighton settlements – probably on the beach again – was swept away and submerged by the sea in a great storm of 1278, the same year the original port of Winchelsea was destroyed. The *Anglo-Saxon Chronicle*, one of our earliest history books, records that Brighthelmstone faced 'bad wind' in 1103, 1114, 1118 and 1121. It still does when our visitors eat too many curries. 1348 was another year that would have challenged our ancestors. Not only was the plague sweeping Britain but Brighton faced yet another storm. Over 100 houses were destroyed in one night in the 1700s and much of Hove was washed away too. These people were tough – their ancestors had survived Vikings, Saxons and now waves. However, storms weren't always a negative experience for the people of Brighton; in February 1630, a Dunkirk warship of 130 tons was shipwrecked in Brighton following a storm and the ship was broken up and looted by the people of the town!

The sea may even once have encroached into the cliffs to form a small harbour, where the fishermen beached their boats. It is even believed the harbour reached as far up East Street as in front of The Sussex pub. Pool Valley takes its name from the pool

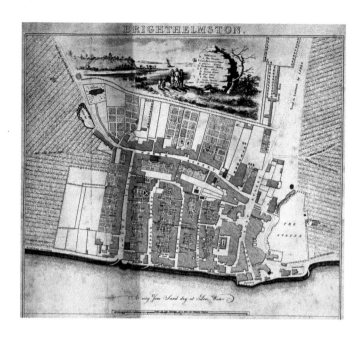

A map of Brighthelmston from the 1700s, the century that bathing first began in the town. (Picture courtesy of Royal Pavilion and Museums, Brighton and Hove)

that was created by the waters from Brighton's now underground stream that not many know about, the Wellesbourne. Born from spring wells coming up through the Downs in Patcham, both the Wellesbourne and the stream that joined it from the Lewes Road Valley (much in need of a name) must have also helped create some sort of river mouth after their journey through a channel through the once swampy and un-level Steine. The Lewes Road Valley stream also made the area the prince had created into his cricket ground a bumpy and marshy quagmire, and its name today (the Level) celebrates its eventual landscaping. Unlike Worthing, however, it seems the sea had little journey deep into Brighton, whereas the coastal, newer part of Worthing was once surrounded by the sea on three sides at high tide. In Brighton, the sea used to enter the sewers at high tide, which apparently made the early sewer tours interesting when coupled with high levels of rainwater!

The sea might have wiped out early Brighton and still threatens sewer tours today, but it was the saviour of the town. Lewes physician Dr Richard Russell's decision to write in 1750 'Glandular Diseases', or 'A Dissertation on the Use of Sea Water in the Affections of the Glands', suggesting that seawater was healthy for you to be in, on, near or even have within you, was one that unhealthy rich Londoners soon picked up on. This meant that moving his Lewes practice to Brighton to set up his surgery (or 'hydro') near the sea made sense. Russell's eminent patients followed him to try his sea cures and soon Brighton had replaced Bath and Tunbridge Wells as the annual destination for the great, the good and the gout-ridden to try to prolong their lives. Seawater was soon pumped into bath houses for those too delicate to be dipped by one of Brighthelmstone's sturdy bathers and it eventually even ended up being imported into the wealthiest hotels. It was also bottled and sold to Londoners unable to travel south.

For its opening in 1864, the Grand had seawater transported via its pump house, which is still a café below the hotel in the seafront arches. The Metropole, which opened twenty-six years later, went a step further and had hot and cold seawater as well as hot and cold tap

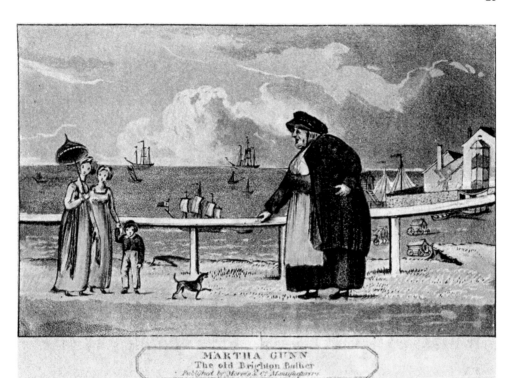

MARTHA GUNN
The old Brighton Bather
Published by Merrys & Co Manufacturers

Above: Martha Gunn, Prince George's chief bather and butter stealer! (Picture courtesy of the Brighton Society of Print Collectors)

Right: 1890s' advertisement for the Brighton Metropole, which had hot and cold seawater on tap in its bathrooms. The bottom-left corner of this advert features its Turkish baths.

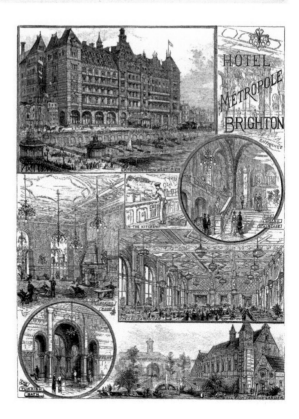

The Hilton Brighton Metropole, Grand Hotel and Brighton Centre. (Courtesy of Kirstie Elliott)

The Metropole today.

water piped into its bathrooms. The richest of the sea-facing Hove terraces and villas also had access to the briny water via large tanks that are still under Hove seafront. Derren, one of the managers at the Metropole, has recently found not just a huge tunnel under the hotel that seems to be an unused Victorian sewer but also a huge vacant space where the long-lost famous Turkish baths of the hotel perhaps once were.

Something Brighthelmstone once had was a port. Despite not having any natural harbour for centuries, and even then not one of any size, Brighton was officially deemed a port between at least the 1300s and 1860. The 'Port of Brighton' was designated as being between two markers on the beach between Ship Street and West Street. Brighton was used as a cross-Channel port to France for many years and the Chain Pier, Brighton's first pier, was built in the 1820s so that cross-Channel steamers could load and unload passengers more quickly than having to rely on small boats to ferry passengers to and from the beach. The fact that going via Brighton was the quickest route to France from London (Dover to Calais is quicker but it took longer to get to Dover from London than Brighton) helped Brighton become the busy town it was. Brighton as a port was eventually abandoned as storms and shipwrecks made it unviable, as well as the rise of nearby Newhaven, but its years of glory gave Brighton the impetus to create an artificial harbour, first around the Chain Pier and then eventually more eastwards, ending in plans for the Marina in the 1960s. Being a port back in 1805 also gives Brighton a unique claim as it meant Brighton was the first place in the UK to announce the victory at Trafalgar and the death of Nelson (it was announced from the Pavilion). Brighton was the place that got the news first, as well as often making it.

Over 150 years later, Brighton was in the news in the 1970s with the construction of Brighton Marina. The marina is 'Brighton's Cote d'Azur – only nearer', as it was marketed back then. With a tradition as a cross-Channel port, it was evident that there was the demand for a place in Brighton for boats to dock and passengers to embark and disembark

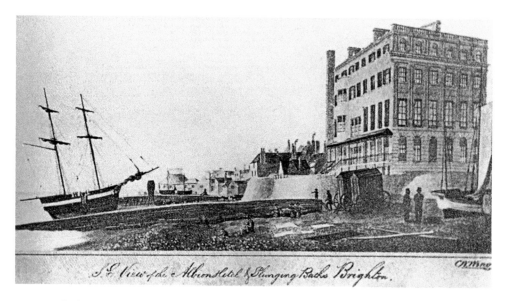

Boats on the beach by the Royal Albion back when Brighton had an official port on the beach.

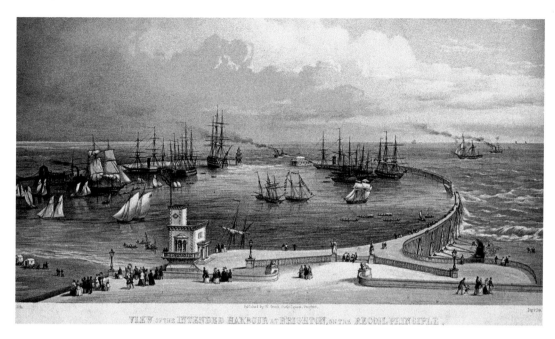

A nineteenth-century plan for a harbour linked to the Chain Pier predating Brighton Marina by over a century. (Picture courtesy of Royal Pavilion and Museums, Brighton and Hove)

Black Rock as it looked before the Marina was built, once a destination for Volks' passengers seeking a fake smugglers' tunnel.

from. The Chain Pier was built for this purpose, not for entertainments as piers provide today, and numerous schemes involving a man-made harbour were proposed over the years. Kemp Town had a temporary harbour when the estate was being built in the 1820s

but by the late 1960s, local businessman Henry Cohen was the driving force pushing for a new marina, first nearer Kemp Town but then in its eventual position in Black Rock. Its idea was simple: provide a home for the boats of those who want a large, exciting city next to where they berth. The south coast had a shortage of places for the increasing number of boats at this time. We forget just what a huge engineering undertaking it was – we have the largest marina in Britain, and before the building of the Channel Tunnel, it was one of Britain's most ambitious building projects, along with the Thames Barrier. Approximately 1,850 metres of concrete walls now project into the sea, meaning 126 acres of what was once the sea is now mostly inhabited by humans. It was only possible from lessons learnt from the construction of the 'Mulberry Harbours' in the Second World War. The harbour walls are made of 110 concrete caissons, huge concrete 'drums' each weighing 600 tonnes, which were put in place at the rate of one every nine days between 1971–76 and filled with 1,200 tonnes of sand. Several men died building this voluminous venture, which has and does provide thousands of jobs for the city and has ensured many can now keep their boats on the south coast, and that Brighton's fishing fleet has a permanent home once more.

We normally talk of time and tide and so it seems appropriate to link our mention of the waves to discussions of the chronological. Brighton just misses being on the Greenwich meridian, that honour going just over the border to Peacehaven, although, like Greenwich, Brighton has a golden timeball on top of the Jubilee Clocktower near Churchill Square. Designed by Brighton genius Magnus Volk, the building not only told the time with its four clockfaces but has a ball that, unlike its Greenwich equivalent, rose every minute and sank on the hour every day. Brighton's had no need to move at the same time as that of the Royal Observatory, as theirs did so at 1 p.m. because the Astronomers Royal were too

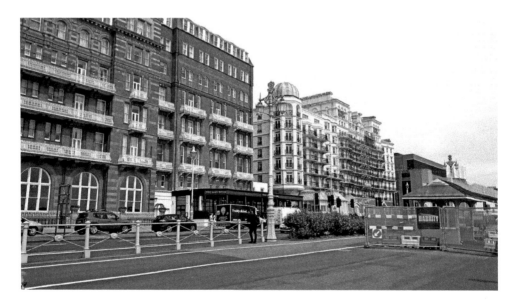

On the south-west corner of the Metropole is the Salt Room, where Maples furniture store used to stand – the Metropole's official decorators and furnishers had their own store next to the influential hotel.

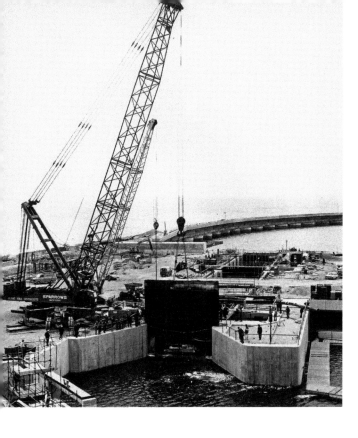

Brighton Marina under construction between 1971 and 1976.

busy at midday observing the horizons to operate the machinery at that time. Greenwich's timeball helped sailors in the Thames, but Brighton's just annoyed shopkeepers as it emitted a sharp whistling noise and was soon left to malfunction. Further down towards the sea, another timeball operated on a furniture shop, Maples, that was where the Salt Room is today, and had supplied the Metropole with all its furniture and decorations. That also stopped working but Brighton provided another unusual method of telling the time, the voice of the talking clock. The once-popular method of finding the time by telephone was voiced by Brighton resident, Sara Mendes de Costa, who was the fourth person to provide the voice behind this service, from 2007 onwards. Should the flights in the British Airways become as regular as clockwork then we may find ourselves setting our watches by the world's most slender tall tower. Should the team at the i360 decide to announce each new year with a rise and descent of the pod, then we will also have a whole new way to measure periods of time.

Another time-related secret that Brighton has never revealed is why it became Britain's leading place for the construction of clocktowers. The first public clock appeared on the old Tudor Blockhouse, the military building defending the town, which also had the town's dungeon at one stage. It was in the Victorian era, however, that the builders of Brighton went mad for the construction of time-keeping towers. As the writer Colin Cunningham said in *Edwardian and Victorian Town Halls*, there is a mystery in why the Victorians felt we needed so many elaborate structures as clocktowers. Today, they provide a mysterious air to Brighton. I had the honour of suggesting to Peter James that the red-brick and terracotta clocktower in Preston Park might make a good murder site for Roy Grace, his

fictional Brighton detective, to have to follow up. It also features in the novel by Brighton author Thomas Stakeman as one of the series of portals that teenage time-traveller Ray Hadley and his gang of 'Chronomen' use to move through time and space to defeat the evil Tionites in the children's novel, *Chronophobia*, set in 1990s' Brighton. One secret I'd like to discover is what happened to the clocktower attached to the Metropole's Clarence Suite, the chapel designed by Alfred Waterhouse as part of the hotel in 1890. The Clarence is still in use today as a function room of the busy hotel, but its clocktower disappeared by 1963 as the hotel developed its surrounding gardens into conference and exhibition halls.

Returning to the watery stuff that provides 180 degrees of the view of the i360, in the 1970s the construction industry in Brighton was busy building another waterside technological marvel – Brighton Marina. Boozy lunchtimes were also big affairs for those in the construction industry, something we'd find unimaginable in our days of health and safety today. The main task was the placing of huge concrete caissons forming the marina wall in the correct place, using huge cranes and the construction of the large inner walls. One day, the workmen succeeded in putting another part of the huge inner walls in place at high tide, and then decided to visit their complicated achievement by a visit to the Bush Inn, the favoured pub of the Marina's builders. The lunchtime drink became rather a protracted affair and it was only when the men returned to the worksite much later they realised they'd forgotten about the big difference between high and low tide in Brighton. A very expensive and extremely heavy crane was now dangling 30 feet in the air, still attached to the section of the wall it had helped put in place hours earlier!

Air

The skies over Withdean were apparently the location for the sighting of a UFO in the 1950s. Sheila Burton was a resident of the wealthy Brighton area who awoke early one morning in September 1951 at 6.30 a.m. and saw a flashing object looming high in the sky, rapidly dive-bombing down towards her garden lawn. According to John Hanson, who recalled what Mrs Burton had witnessed in a letter to the *Argus* in 2008, the spacecraft then revealed panels that opened as it landed, from which three 5 to 6-foot tall men exited and had 'bald heads, odd expressionless faces, small pointed noses and ears'. They lacked lips apparently, but had 'deep set eyes and were dressed in khaki one-piece garments'. Despite carrying weapons of some sort, they thankfully didn't use them on Mrs Burton, Mr Hanson reported and after their close encounter, decided to return to their spaceship, which was able to rocket vertically into the sky. UFOs have also been reported over Ditchling Road, Woodingdean, Hove Park and Shoreham over the years before drones were commonplace in our skies, as they are increasingly becoming today.

Brighton is the greenest of Britain's cities (politically at least with the country's first Green MP, Caroline Lucas) and has always tried to keep the air clean years before Lucas's election in 2010. With Volks' Electric Railway we had the world's first and longest continually running passenger electric train service. This means we have led the way in non-polluting transport, but we also held exhibitions a century later on the environment years before being environmentally friendly was possible. The Metropole's Scitech exhibition in 1989 had local schools and universities all demonstrating how they were keeping green, highlighted the dangers of polluting rivers and of lead in the atmosphere.

It seems strange now that the May exhibition of that year was trying to get motorists to give up leaded petrol and convert to unleaded! Brighton also needs to be acknowledged for ensuring residents have lots of green space with our wonderful parks, despite being near to the Downs. Brighton even turned literally green once (or at least the sea between the piers did) in 1967 in the first year of the Brighton Festival when an attempt to create a huge red, white and blue union jack flag on the water ended up with a murky green covering of the briny.

DID YOU KNOW?

Should you stand on what sand Brighton has, obviously at low tide only, you can connect with the past in a way that is not only amazing, but not many people know about. The small rivulets of water that snake down under the pebbles and form minute deltas in the sand to the east of Brighton's Palace Pier are actually spring water escaping underneath Brighton and can be extremely old.

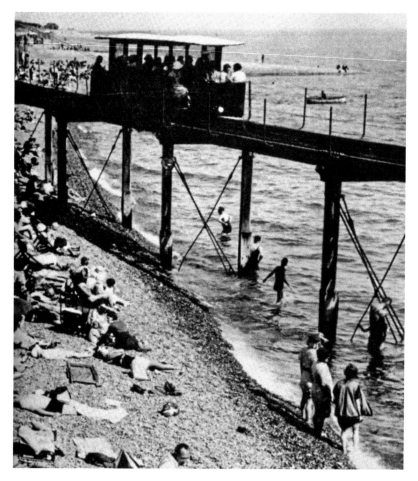

Volks' Electric Railway. The oldest passenger electric railway in the world, here suspended in the air as it was before coastal deposition occured.

Above: Brighton's Metropole hotel once offered rooms facing its Italian gardens for those too genteel to face the sea air.

Right: The British Airways i360, where flight in its pod, or 'donut' as it has been nicknamed, take you 162 metres into the air.

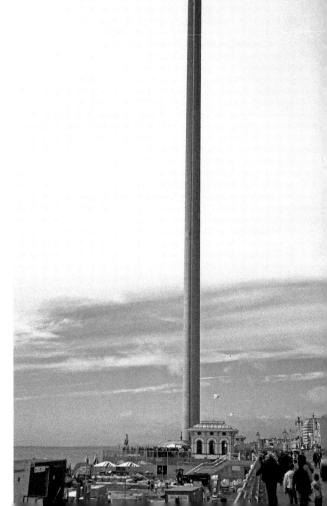

Rising up into the air since summer 2016 is Brighton's wonderful British Airways i360. Brighton has a tradition of exciting, technological, controversial, world-famous and game-changing buildings and the British Airways i360 is no exception. At 162 metres tall (the pod rises to 138 metres), it is the country's tallest observation tower outside of London, the world's tallest moving observation tower, the most slender tall building on the planet and also the world's first vertical cable car. Visitors can see up to 26 miles in the distance with a 360 degree view, hence its name. It is vital in helping continue the regeneration of West Brighton and already looks due to meet its projection of bringing 700,000 visitors a year to this area of the city which was neglected in the 1980s and 1990s as development centred around the Palace Pier. As well as taking Brightonians and visitors for a ride on the 'pier in the sky', the West Pier Trust will eventually benefit as it will help to pay for a new West Pier.

There's an awful lot to like and Brightonians who still aren't sure about our latest piece of engineering excellence should take heart that Regency Square residents back in 1866 weren't sure about the West Pier either. The British Airways i360 has been a hugely complex engineering task, but with the creators of the London Eye, the world-famous Marks Barfield Architects, behind the design, the i360 is, in all ways, a building that has risen to the challenge. Brighton is, and will be, looking up in more ways than one. Anything secretive about it? Local author Peter James toured the foundations as it was being built, so perhaps a fictional murder victim is already buried underneath the tower. From the ground to back in the air again, few people know the tower weighs the same as 52,000 seagulls – that's the birds of course, not the football team!

The building site of the i360 on the site of the near-destroyed West Pier.

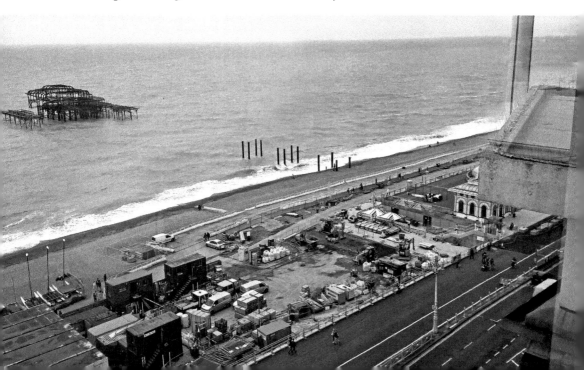

The foundation of the i360 as it was being built. A possible murder site in the fictional world of Roy Grace?

2. Hell and High Water

Brighton and Religion

Apparently hell has many fires, and Brighton has had its fairshare over the years. It's also been a town determined to keep people out of hell from the earliest days of settlement, with a possible Roman temple; some historians think this was nearly 2,000 years ago, on the north side of Springfield Road now covered in blocks of twenty-first-century flats. Church building was still on the mind of Brightonians much later in the nineteenth century, as many were built during that period. St Bartholomew's in Ann Street is seen today as a rare and fantastic example of a church. (Some people have said the fake backdrops of the city landscape out of the windows of the office in the 1980s television programme *L.A. Law* included half of St Bartholomew's in the background – see what you think!) Despite many lost church buildings, we still have an amazing range of beautiful church architecture in our incredible city and need to thank religious Victorians for that. We also owe religious folk one other debt as, without them, more of Brighthelmstone would have washed away – in 1723, churches all around the country paid to rebuild groynes on the seafront to stop the loss of any more of the town.

Not many people realise that Church Street is so called as it leads up to Brighton's oldest church, and arguably Brighton's oldest building: St Nicholas's. The Knab or Pool Valley may be older, but it is certain any buildings in these two locations were destroyed by the French. St Nick's also had a vital function for several centuries as a navigational beacon for sailors at sea approaching the town. It may have helped back then, but the church today provides a mystery for us today: why was the town's church so far away from the town, up on a hill, especially when St Nicholas is linked to the sea and therefore to the fishing town below in the valley? Its lofty location might suggest it had a role in the plague from the 1340s in keeping plague graves away from the town or perhaps there was an older Brighton community around St Nick's? However, no evidence has ever been found to suggest either. The second mystery is why the Domesday book of 1086 records Brighton as having a church but there is no evidence that St Nick's is that church. So where was Brighton's earliest church? Even more mysteriously, St Nick's has a decorated font that dates from 1160–70 but it is mysterious why an interior part of the church is older than the exterior. Could this font, the oldest physical part of Brighton be from the older church? It is believed some of the stones of St Nick's were from the earlier church.

The Normans who controlled Brighton after the Battle of Hastings were very religious and imported their religious traditions and clergy over here. Near to where the town hall is today was built Bartholomew's Priory here. This meant for several centuries from the 1120s a large part of the old town of Brighthelmstone was taken up by a huge religious complex – a bit like the one at Lewes Priory where the ruins are still evident today. This

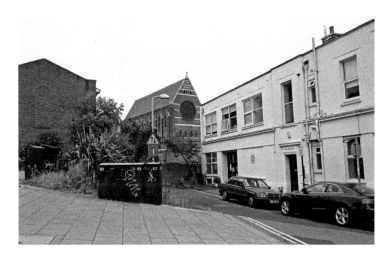

St Bartholomew's, Brighton's only Grade I-listed church, built by Wagner.

means that Brighthelmstone was an important religious town that would have been visited by archbishops. Talking of archbishops, one Saxon archbishop in AD 959 was called Byrhthelm or Beorthelm – could this be the same Saxon the town was named after? This idea might seem far-fetched, but then the also-important Preston was one of eight manors owned by the Bishop of Chichester. In fact, Preston's name in Anglo-Saxon, is 'Preste-ton' – the holding of a priest, so it's not that impossible that once Brighton was an important religious settlement too.

The French burnt the town to the ground in 1514, providing us with our first ever picture of Brighthelmstone (although it's inaccurately recorded as 1545 in the picture – the year of a second attempted but less successful attack). They also provided us with an industrious group of economic immigrants from the 1500s as French Catholics increasingly turned against their Protestants. The Huguenots, one of whose descendants is Nigel Farage, are believed to take their name for the Dutch for 'housemates', did indeed become our housemates. By 1887 there was a 2,000-strong French Protestant community in Brighton, and it needed a church, which is why we have the one-time miniscule French Reform church hidden away in the shadow of the Metropole and facing the Queensbury Tavern in Queensbury Mews. The Huguenots in Brighton left us this wonderful hidden gem, which is today a private dwelling and is the only existing Huguenot church left in the country outside London. It is also the oldest surviving example of a Huguenot church, predating the London one in Soho Square by six years. Brighton's Huguenots had an impact across all class of the town's society as they worked in many professions such as French governesses, hotel and office staff and servants as well as being some of Brighton's most successful businessfolk. One other thing left from the Huguenots is the time capsule that was buried in 1887 under the central foundation stone of the church. When the congregation dwindled and the church was sold off in 2008 to a private owner, the new owner thankfully left the capsule where it was, complete with a newspaper, bronze medal and a number of coins commemorating Queen Victoria's golden jubilee of that year.

York Place around St Peter's was originally called Church View and is nothing to do with the northern city, but due to the fact the builder of the area was the owner of the

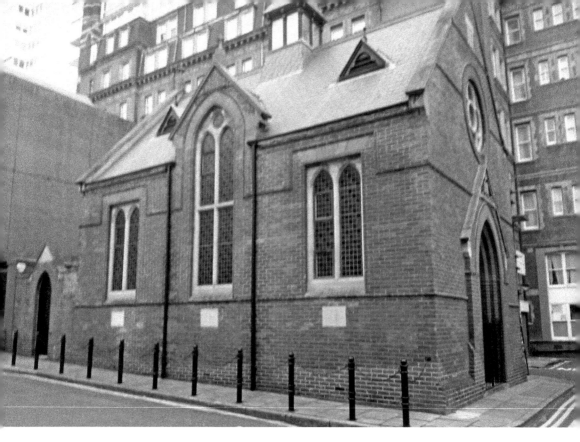

Above: The French Reform Church. This Victorian gem in the shadow of the Metropole is one of only two surviving, but is a private residence today.

Below: Brighton in the 1760s with a view of St Nicholas's. (Picture courtesy of Royal Pavilion and Museums, Brighton and Hove)

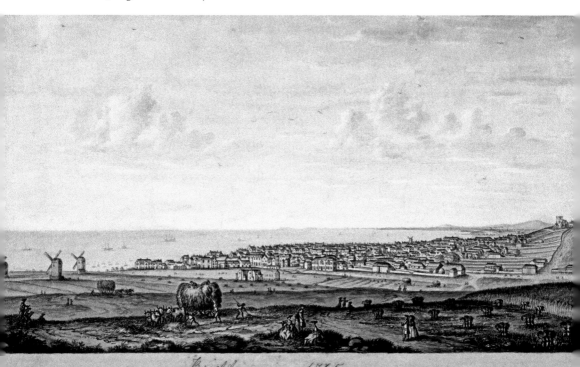

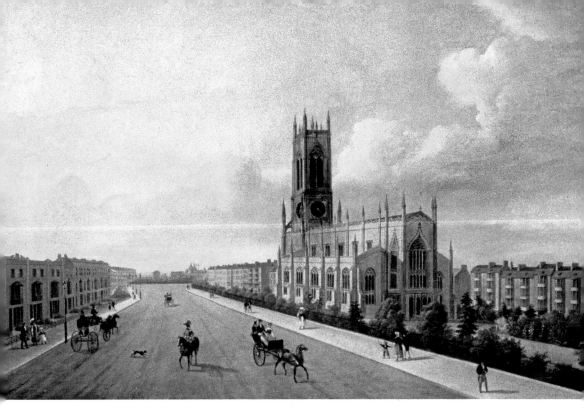

St Peter's Church, seen as Brighton's unofficial cathedral. (Picture courtesy of Royal Pavilion and Museums, Brighton and Hove)

Royal York Hotel, today the YHA. Prospect Place, to the east of York Place was so named because of its view south down to the Steine, which became blocked by the building of St Peter's Church. Therefore it had to change its name to St Peter's Place, which it still is today. The house owners there may have lost their view of the sea, but in return gained a view of Brighton's grandest church at that time, built by Charles Barry, the architect of the Houses of Parliament. Today, St Peter's is seen as Brighton's unofficial cathedral and not many people realise that the grass outside it is kept green not by divine intervention but partly because the Wellesbourne stream runs nearby underground.

A slightly easier secret former chapel to find is the wonderful Clarence Suite, as it is called today. As well as blessing Brighton with his one and only seafront hotel and public building, the Metropole Hotel (today the Hilton Brighton Metropole) the illustrious Victorian architect Alfred Waterhouse, designer of the Natural History Museum, also endowed Brighton with a 'secret' chapel and ballroom that we still have today – but is a well-kept hidden Brighton secret! Tucked behind the Metropole's main building, today it is deep within the collection of conference and exhibition halls that are part of the hotel complex. Waterhouse designed the 'Clarence' as part of the Metropole's Italian gardens what were once the spot for wealthy visitors to the hotel to hold romantic walks in. The gardens were lit with electric light, which was unusual, but the chapel and ballroom were where romance went a step further with dances, 'Cinderella' balls and even weddings. The Clarence had its own clocktower, now sadly demolished but the ballroom is still much

used today. So, partygoers at the hotel today may not realise as they boogie that they are dancing in a unique 125-year-old architectural gem. The Clarence Suite at the hotel is still the same building today. Worthing High School and Cardinal Newman still use the Clarence for their proms and many a happy bride has been given away in this unique hidden Victorian masterpiece.

The Victorians believed that sending criminals to hell was the job of the hangman and Brighton provided one of the last ever men to do this job. The last person in the British Isles ever to be hanged for forgery? That'll be banker Henry Fauntleroy (1784–1824), who was executed in 1824 at the hand of another Brightonian, hangman Jemmy Botting, for forging customers' signatures on cheques. This was obviously a time when bankers did get punished for wrongdoing! 100,000 people watched his public execution, which took place outside the famous Newgate Prison in London. A group of people we perhaps see today as wonderful, but that many Edwardians wished would end up in hell, were the Suffragettes and the last surviving Suffragette was of course a Brightonian. What else would you expect from the city that has always been forward-thinking and radical in its views?

Brighton is so radical a place it even built one of its churches underground. This secret place of worship is only accessible to the staff of Churchill Square Shopping Centre today, but once was one of Brighton's many places of worship and located in Russell Street. Russell Street was one of the many streets that was demolished to make way for the original 1960s' shopping centre, but the one-time Church of the Holy Resurrection went through the fourth of its resurrections and is today still hidden as a storeroom under the shopping complex.

Churchill Square, hiding a secret underground chapel beneath its stores. (Picture courtesy of Royal Pavilion and Museums, Brighton and Hove)

Its first incarnation was in the 1876 as one of the number of churches built in Brighton by Arthur Wagner, builder of St Bartholomew's and vicar of St Paul's in West Street. Plans for the church were rejected by the council at the time (or corporation as it was known) as it was deemed too high for the area. Wagner, known for his eccentricities, had already paid off officials to allow St Bartholomew's to be higher than it was meant to be but this time was told to stick to the given height. Undeterred, the vicar used a method that St Martin's Church in Lewes Road had employed to a lesser extent and built the church underground – although this time totally underground.

The subterranean services didn't seem to deter new parishioners as the church's programme of marriages, baptisms, christenings and other services all were busy. Funerals had the added benefit that those whose lives had been cut short were already under the ground too!

Left: St Bartholomew's was higher than it was meant to be, but didn't go underground.

Right: The altar inside St Bartholomew's, located at the unfinished north end of the church.

The life of the church was also cut short though in 1908 when it was forced to close and it faced years lying dormant before being converted to a storeroom for the local West Street Brewery, who found its cool temperature ideal. The chilly rooms also provided perfect conditions for a meat-storage facility. It's final resurrection was in 1963 when it became little-known dark and empty storage rooms under the huge shopping complex, which remain accessible only to a few of today's shopping outlets since the centre's rebuild between 1996–98. Few people realise a dark place where funerals were once carried out still exist, deep and hidden below Brighton's busy and bustling Churchill Square. Perhaps Peter James has an exciting location for a lonely murder scene or action-packed finale for one of his Roy Grace detective novels hidden below one of Brighton's busiest locations.

DID YOU KNOW?

St Bartholomew's Church in Ann Street is technically unfinished and so millions of visitors travelling into Brighton by car each year see its unfinished north side – only 142 years after it was built! It was also meant to be much lower, but Father Wagner, the wealthy vicar behind much of Brighton's Victorian church building spree, decided to bribe the planning regulators so that he could build his church higher than Westminster Abbey, which it still is today – just.

Jewish Brighton

Brighton and Hove have been enriched and invested in widely by our Jewish community and many of the city's leading lights have been Jewish. Back in 1766, Israel Samuels was Brighton's first recorded Jewish citizen and a Jewish community was established by the 1780s, which is where Jew Street today in North Laine takes its name from. One of Brighton's earliest chief constables, Henry Solomon, was Jewish. He was chief constable in Brighton police station when it was based in the town hall and died at the hands of an arrested criminal, who killed him with a poker in 1844. Thousands of townsfolk attended his funeral and the town started a fund for his widow and children; Queen Victoria herself donated £50. Solomon was hugely respected in the town, filling a number of roles as well as being one of the town's first two police chiefs and a watchmaker!

Moving westwards into Hove, Adelaide Crescent, Palmeira Square and the surrounding streets wouldn't have been built without Isaac Lyon Goldsmid (or Baron de Goldsmid de Palmeira as he later became known) jumping in to save the development when Thomas Read Kemp became insolvent. This is how Palmeira Square gained its name. Goldsmid became very closely linked with the town, becoming an international hero after solving a nasty dispute between Portugal and Brazil, which gained him his grand title. He was also the first Anglo-Jewish citizen to be made a baronet. Brighton's Middle Street synagogue was not the town's first (that was in Jew Street in 1792) but is the country's first to have electricity, and was consecrated back in 1875. It has the second most impressive interior of any Brighton

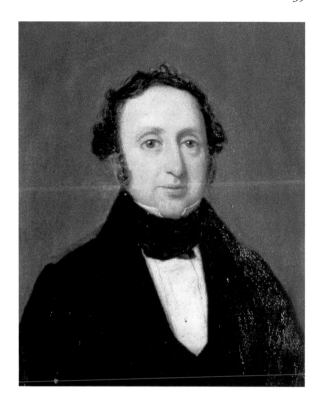

Henry Solomon, the Jewish chief
constable in Brighton police station
who met a brutal end with a poker.
(Picture courtesy of Royal Pavilion
and Museums, Brighton and Hove)

building after the Pavilion and also has a window recreating the image of Lady Rosebery, the
Jewish wife of Lord Rosebery, the prime minister. Without Jewish architect David Mocatta,
who built Brighton station in the 1840s, the experience of the millions of visitors arriving
here each year would be much poorer. Without finance from Sir John Howard, a Jewish
engineer, entrepreneur and railway director, the Palace Pier would be unlikely to have ever
opened in 1899 as it had already faced bankruptcy and delays. Another investor, Henry

The American Express Community Stadium (or 'Amex' for short).

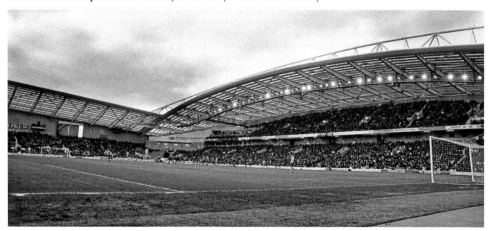

Cohen, brought Brighton Marina to life and Lord Lewis Cohen, our Jewish mayor between 1956 and 1957, also created what became the Alliance and Leicester Building Society, which helped bring affordable mortgages to the masses. Even today, without our leading light of our Jewish community in Tony Bloom, we wouldn't have had not just a chairman of Brighton and Hove Albion FC but also its major investor in the wonderful Amex Stadium.

Fire

France has contributed many peaceful immigrant groups to Brighton and Hove; much of our cuisine and many students come here from our Gallic neighbour every year to study in our city. However, Brighton was totally destroyed by fire after a French raid back in 1514. Henry VIII's wars with his former ally, the King of France, led to a series of naval raids between the two countries. Admiral Pregent (known as 'Prior John' by his English enemies who couldn't pronounce his name) was tasked with raiding south coast towns and chose 'Brithampton' (Brighton had various names used at this time and hadn't settled down to using just one) as his target. The lower fishing town was torched, as were the houses in the upper town, so nothing except St Nicholas's, safe up on the hill, remained. A warning beacon was lit on the East Cliff, which alerted local archers who drove the French away. It was too late, however, as the town was in ashes by this time, but at least the town was ready for a second raid in 1545, which had little impact. It seems one of the French warships may also be the wreck off the west of the entrance to the marina today too, so one was either chased and fired on by the English Navy, or more likely sunk. A fortified wall and defensive battery were built to defend the town, the latter of which lasted until the 1800s.

When a ship from Dunkirk attacked in the 1630s, it was chased onto the beach, its cannon used for further protection and its surviving crew presumably murdered. Twenty-one towns and villages in Normandy were burnt down in retaliation for 1514 in a British military raid, led by Sir John Wallop, who was certainly living up to his surname. Thankfully, today we live in peace with our French allies, having taken in a

Like the West Pier, the Palace Pier faced a fire, but thankfully survived.

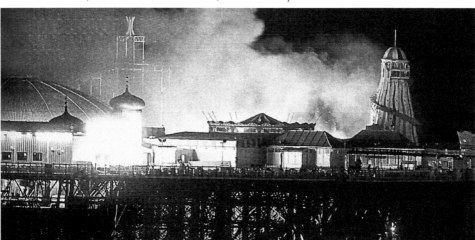

French Huguenot community later on in the 1500s and sheltered many French folk in the Napoleonic Wars and the later revolution of 1848.

The most famous Brighton building to be badly affected by not one but two suspicious fires this century is of course the West Pier and, in this case, it was not rebuilt afterwards. In 2002 and 2003 mysterious arsonists, who were never caught, torched the West Pier not once but twice when it looked that Lottery funding had assured the Pier's future. However, Brighton's Palace Pier hasn't been immune from fires either. Its ghost train became scary for the wrong reasons in the early noughties when it too caught on fire. Thankfully the fire was soon contained and Brighton has at least one intact pier today.

Brighton has had a number of other fires over the years, some very suspicious. The Bedford conveniently burnt down when its owners had put in planning to develop it into a tower block and hotel, and the Metropole also faced a (thankfully) small fire in 1954, during the years it was losing £10,000 a year. Its owner, Harold Poster, thankfully decided to develop parts of it rather than demolish it. That the Hove Town Hall and the Bedford were swiftly replaced after fires rather than restored prompted rumours. Fire even took hold of part of our historic Royal Albion Hotel after a chef's actions. Fire has a more positive role in Brighton today, thankfully. Our wonderful non-religious and non-denominational Burning the Clocks event is a unique celebration of the end of nights getting longer every year, and is due to celebrate its twenty-third year in 2016.

Fire and heat seem to be preoccupations not just of arsonists, but also of the past builders of Brighton's staircases. The Pavilion has a staircase that is not all it seems. It is made of iron and painted to look like bamboo because, when George IV first had the staircase made, iron had never before been used for interior decoration. The whole staircase was originally iron but the king decided it was too cold to touch so he had the top part of the hand rail replaced with mahogany and painted again to resemble bamboo, this meant that his visitors would not get cold hands when holding the rail. This is all part of the exotic fantasy that George IV was trying to create. Another staircase where the guests wouldn't get cold hands was at the Metropole, built seventy years later. This had

Brighton Marina. An ancient shipwreck lies just outside of this artificial harbour, possibly sunk in retaliation for Brighthelmstone being burnt by the French in 1514.

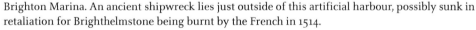

the country's first heated staircase, which was powered by steam and seen as incredibly luxurious at the time. Staircases that might not leave you warm but decidedly chilly, are the ones at the town hall and Preston Manor, which are both meant to be haunted. Cannon Street, between the Metropole and Grand hotels, has two Georgian houses that are designed in an unusual way to save people from fire. The Metropole took over these two Georgian buildings as part of its 1960s' expansion but was not allowed to demolish their exteriors as they were listed. They demolished the interior and replaced it with staircases so today they are empty except for the very expensive fire-escape route they provide. A very unusual use of £2 million-plus Brighton properties, but it is good that the Metropole saved some of Brighton's heritage while keeping conference delegates safe in the event of fire.

DID YOU KNOW?

Regent Arcade off Western Road was where 'Mockbeggars Croft' once was located. This suggests a Franciscan group of friars once lived here, who would have taken a vow of poverty, hence the name. Brighthelmstone was once a very religious place with much of the early town dominated by the Bartholomews Priory.

The Metropole's unusual and very expensive fire escape – hidden in two Georgian townhouses.

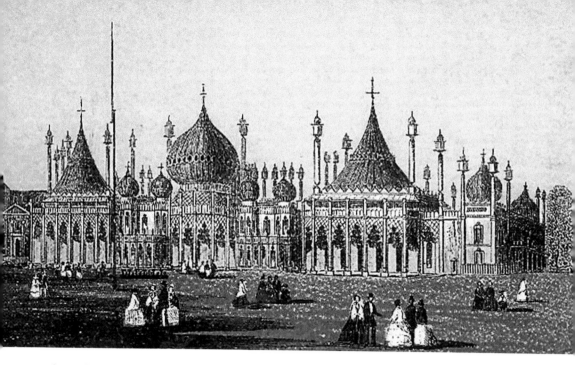

Above: The Pavilion, home to a deceptive and unusual staircase. It also suffered a bhital arson attack in 1975.

Below: The Hilton Brighton Metropole today – home to a very unusual fire escape.

3. Fun and Games

Brighton has always been a place known for its sports. We were one of the earliest homes of cricket, with the game being played at what is now the Level by none other than the Prince Regent. This area, and what is now Park Crescent, were once also a originally the Prince Regent's cricket pitch (one of the earliest in the country, and an early forerunner of Sussex County Cricket Club – which is why we have the Bat & Ball pub still facing it on Ditchling Road). It was then given to the town by Thomas Read Kemp and landscaped by Charles Barry, who designed the nearby St Peter's. In the picture you can see its earliest days – with Elm Grove stretching up behind it, before being planted and thus named (Elm Grove got its name from the planting of elms to mark the route up to the racecourse). Home to public meetings, political marches, circuses and fairs, it is the last of the original town parks as you head north-east out of Brighton for Lewes. Today, although it has many different uses, it would be great if this historic Brighton Park could again be used for its original use as a cricket pitch and get more people playing the historic game at the Level that was once played by a prince here.

The Level – once a prince's playground, now the people's playground.

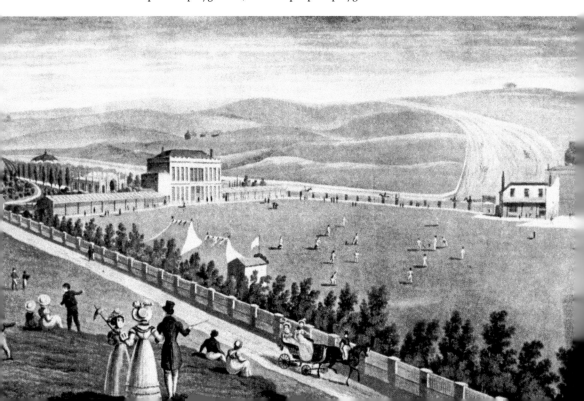

Football has been played by Brighton and Hove teams since the start of the twentieth century, but it is horseracing that was one of the earliest pursuits of well-to-do visitors to the town in the 1700s. The prince was so dedicated to the sport that he built his stables and riding school (today the Corn Exchange, Dome and museum) in 1805, seventeen years before his Pavilion was finally completed. In one year, the government of the time spent more on the riding school and stables than on education for the whole nation, showing the misguided priorities of those in power at the time.

The hills above Brighton where the races took place soon became known as Race Hill, but they were not always named this. Hollywood may have had the film *Black Hawk Down*, but our lofty horseracing course was Whitehawk Down, the Downs in this part named after the birds that once flew above this hilltop area of the town.

It may be little known, but sports venues in Brighton and Hove have been used for other games than they were intended for. The Greyhound Stadium in Nevill Road used to have First Division football teams training there before big matches in the 1930s, 1940s and 1950s before important cup ties. It also held athletics, horseshows, boxing matches, American football and rugby – the Springboks, Wallabies and All Blacks tourist teams all played there. The strangest planned use for a track designed for dogs must have been that of introducing speedway racing to the circuit in the 1970s. Thankfully the trials turned out to be too noisy for locals and the stadium has remained a doggy destination ever since.

Horseracing and the dogs haven't always been our only forms of gambling. Another Brighton first that is little known today is that we gained national prominence and fame as the location of the country's first licensed continental-style casino, following easing of the gambling laws. On its opening in 1962, the casino (in the Clarence Room at the Metropole) was painted blue and gold and was visited by a large number of VIPs. Its most famous early visitor was none other than Ian Fleming, himself no stranger to casinos as author of the James Bond novels, including of course, *Casino Royale*. £500,000 was won and lost in the casino's first fortnight and by 1967, it was still taking the staggering sum for that time of £70,000 per night. The casino moved to nearby Preston Street in 1985 and the Clarence Suite at the hotel still has the safe built into the room, which cannot be removed without demolishing the Victorian building or using a large bomb. Moving from bombs to bombshells, the famous post-war blonde British actress Diana Dors was banned from entering the casino. The reason? She was wearing trousers. The 1960s' bouncers were so strict they still refused to let her in, even when she generously offered to remove them!

Brighton always seems to have been visited by spooks and spectres intent on having fun and games with the city's inhabitants, visitors and especially its pub landlords. It

The Casino, Clarence Room at the Metropole – ready for thousands of customers.

isn't surprising the Druid's Head has several spectres as it was once an old haunt of smugglers, with two suspected smugglers' tunnels underneath its bar. A hooded figure was seen briefly by the stairs in the 1970s by then landlord Derek Woods. A far more glamorous ghost was also seen in the bar by one of the bar staff wearing a red dress. That spook also swiftly vanished after moving towards the stairs. Perhaps the stairs in the Druid's were the scene of some altercation between the two? The Regency tavern's brightly coloured interior hasn't put off poltergeist activity in the past, nor a tall and wispy female ghost who walked through one member of staff. She is said to be the landlady from the 1930s. It also had a girl with a bad limp who haunts the upper floors, believed to be from the 1860s when the pub was a cobbler's shop. She apparently jumped from the first-floor window, when smelling gas from the gas lamps, to her death on the pavement below and her footsteps were frequently heard running across the floor to the window. The now-closed Stag Inn off Edward Street may instead have had a ghost who was a member of staff, or at least a butcher. The 300-year-old ex-coaching inn in Upper Bedford Street was visited by a tall spectre wearing an apron and two black armbands, the sign of mourning. Perhaps he was a chef whose food killed two patrons! The staff christened him Albert and even after he stopped appearing from 1982 onwards any beer barrel taps that mysteriously turned on or off were accredited to him. Obviously a being ghost must be thirsty work.

Brighton is said to be one of the most haunted places in the country, with only York having more spooks and spectres. The council even employed an investigator into psychic sightings until the 1990s. George IV and Maria Fitzherbert still apparently reside in their respective homes from when they were alive, as you would expect. Meeting House Lane is said to be the site of Brighton's most famous non-royal ghost as it is haunted by a nun from the ancient St Bartholomew's Priory, which was burned down by the French in 1514. The nun was walled up in a room there and starved to death as monks weren't allowed to get blood on their hands when murdering someone. Her crime? Sleeping with a soldier. Dressed in a grey habit, the lanes-based spectre now apparently glides through a bricked-up archway and into the Friends' meeting house.

DID YOU KNOW?

Martlets, Dolphins, Sundowners, Briovians and Gems were all names fans of Brighton and Hove Albion have been labelled with over the years, before the name 'Seagulls' was finally settled upon, apparently as a comeback to rivals in 1975 whose chant was 'Eagles, Eagles!'

4. Sickness and Health

This place that we live or work in, or you may be visiting, is a place that has been somewhere that has helped many people live longer, healthier and better lives. The idea of a health-giving resort by the sea was only created with the advent of Brighton changing from a fishing town to a bathing place for the rich and regal. Before Brighton gained fame, rich Georgians had to make their way to Bath for relaxation and to enjoy the waters there – but this was miles from London and inland. Brighton was a whole new package – better air, spring water (in St Ann's Well Gardens in Hove), the chance to dip in the sea and emulate the royal family. This had never happened before – the summer residence of the Head of State was also a place to lengthen your life! No wonder Thackeray called the place 'Dr Brighton'. The fact that Brighton provided a place where people could escape chances of polluted drinking water, breathe good sea air, exercise and be happy must have lengthened countless lives and even saved many. Water from purified chalk aquifers, fresh breezes blowing away pollution, healthy walks on the beach and downs – Brighton helped bring about the idea of people wanting healthier lives. Just how healthy Brighton was is clear by the way it was known as 'London's Lungs' after the advent of

St Anne's Well Gardens. Brighton and Hove not only had seawater cures but has a convenient spa too.

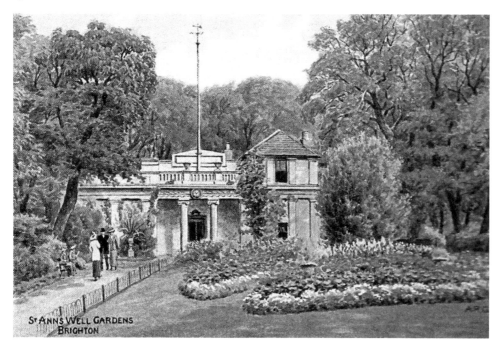

St Ann's Well Gardens
Brighton

trains smokily chugging through London. Still today, Brighton is a healthy haven of vegetarians, gym members and outdoor types and this is why Brighton continues to help people have a longer life expectancy than other places.

George IV's younger sister Amelia, despite having a more sympathetic ailment than her more garrulous brother (painful knee versus swollen neck glands, probably overeating in other words) was not sent here to recuperate. George III decided that Amelia would be safely away from George's less-than-positive influence, which meant that he had to visit her 11 miles away and when she came here she wasn't allowed to leave her carriage. A more successful visit for a poorly child was Winston Churchill – who was sent here as a sickly little boy to be schooled between 1883 and 1885. Weakened by his hated experiences of his previous school, Churchill soon succumbed to serious illness and perhaps it is possible that being in Brighton saved him and ensured we had our war-winning prime minister. Not only did we provide his favourite pursuits of both swimming and horse riding, which encouraged his health to improve, but his family's physician was based here, which meant he was able to nurse the sickly child, who was near death for five days and nights, rarely leaving his bedside.

Depending on your point of view, Brighton's pubs can either add to one's lifespan by providing good company, conversation and solace in bad times or they can ruin lives and relationships. Brighton still has over 300 pubs of all kinds to endanger the health or improve it and should you want the exercise of walking to a pub but no actual pub at the end, then the following pub crawl is recommended. The following are all lost pubs

The Mercure Brighton Seafront, once the site of the Norfolk Inn. An example of Brighton's many lost inns.

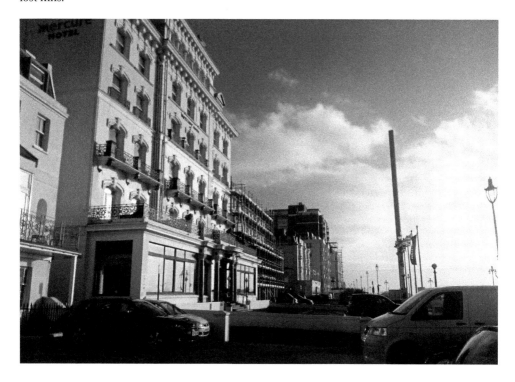

The Metropole's extension plans in 1980s, including what was then the Cannon Pub on the bottom right (today The Salt Room).

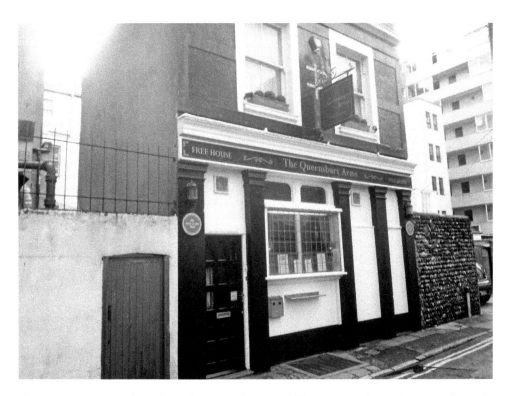

The Marquess of Queensbury shares the name of Oscar Wilde's nemesis and is Brighton's smallest pub.

of Brighton, so you can happily crawl between them without ever getting intoxicated as you cannot go to the original tavern. The Norfolk Arms, built in 1824 was demolished in 1864 to be replaced by the Norfolk Hotel, today the Mercure Brighton Seafront. The New England Inn on New England Road was replaced by a centre for homeless people using shipping containers. The Running Horse runs no more either; it was demolished along with most of King's Street to provide the car park that obliterated an early Brighton street, full of character houses that would be loved and cherished today, much like Hanover. The car park is now the one between Church Road and North Street, which we enter by Barclays Bank. King's Street, named after George IV's father, George III, is now a tiny stub of a road with a hideous twentieth-century concrete monstrosity dominating the road. The Cobblers Thumb, known as the New England Inn on New England Road was a proud Victorian boozer that resisted the roar of lorries taking the old corner for many years until last year when it was finally demolished. It has been replaced by a living and enterprise centre for the homeless, built from recycled shipping containers. The Cannon Pub is now the Salt Room, having also been Bar 106 since its 1981 opening; there was originally a Cannon Inn, taking its name from Cannon Place, now under Churchill Square. London Arms, City of Hereford Inn and the Star in the East are all other lost pubs whose lost locations you will even struggle to find today, as the road layout is much changed since they were demolished.

At one point in Brighton's history, there were 110 pubs within half a mile of the Palace Pier. Search beyond the seafront pubs beloved by tourists and daytrippers and there a wonderful treasure trove of brilliant backstreet boozers, some hidden well away. The Basketmakers and the Prestonville are two wonderful hidden gems, both of which used to belong to the Gales brewery. The Basketmakers even has hidden messages for visitors to find. The 'Pub With No Name' in Hanover is well worth the uphill walk and its Sunday roasts were voted best in Brighton by Source. The Chimney House in Prestonville is wonderful, as is the Open House next to London Road Station and means you can even do a pub crawl back and forth across the Lewes Railway line footbridge to the Railway Hotel. For a fantastic proper Irish pub that is hard to find but worth the detective work to take you to St Martin's Street, The Bugle is a great Brighton mix of students, regulars and residents. Not far from there is the Park Crescent and moving across town, The Cleveland is a good accompaniment to a walk around Blaker's Park, one of Brighton lesser-known and more underrated parks. Back in the centre, the Fiddlers' Elbow is another great sidestreet pub, but for a tiny pub, try the Marquess of Queensbury, hidden down the west side of the Metropole and looking across at Brighton's historic French church.

5. Cash and Carry

Wealth, Movement and Transport

Brighton has had numerous fortunes spent on it since its earliest days and it is intriguing to try to piece together the worth of the town, just by adding together the cost of its main buildings and the cost of repairs and improvements to them. Not all owners of our buildings are willing to say what they paid for them, but it is fun to guess the costs of a real-life game of Brighton monopoly! For example, the Pavilion cost between £500,000 and £1 million in the 1800s with all its redesigns and rebuilding, and it cost the town £50,000 to buy in the 1850s. The Metropole cost a massive £57,000 to build in 1890 and was last purchased for £65 million. It had £2.7 million spent on it in 1986 and millions more in the last few years alone. The Grand's construction meant spending on a grand scale, as it cost £160,000 to build in 1862–64. Its owners briefly considered demolition in 1984 after the IRA bombing but thankfully they opted for restoration, which was a snip at £10 million! The Royal Albion cost £7 million to repair in 1998. The Old Ship Hotel was valued at a bargain £5 million in 1999 and had £2 million spent restoring it, with further renovations inside. The Jury's Inn Waterfront cost £25 million when built between 1984 and 1987 and half of its 204 rooms were refurbished a decade later in 1998–99 at a cost of £1.09 million. The Norfolk Hotel (now the Mercure Brighton Seafront) was renovated, extended and improved for £2 million in 1985 and it is expecting a massive refurbishment with vast foreign investment at time of writing. The Brighton Centre cost £9 million, £6 million more than was estimated in the early 1970s. The Marina also was meant to cost far less than the £41 million it cost to build – without any of the massive developments since then. Compare that with the £30,000 cost of the Chain Pier, another structure to defy the waves, and it seems like a veritable bargain!

A very cheeky Brightonian was our 'mayor' in the 1600s, Nicholas Tattersell. He helped Charles II safely escape to France during the Civil War, but he was determined that the one-time fugitive king should remember just who had done it. He was not only paid £200 (a fortune then) by Charles for the voyage, but also another large sum when Charles was crowned Charles II in 1660. Tattersell put just a bit of pressure on the new king to get this, sailing his vessel up the Thames to remind Charles just who had saved him. Tattersell bought the Ship Inn in Ship Street with his new fortune and his vessel was commissioned into the Royal Navy, becoming the *Royal Escape.* Tattersell was made a naval captain for a while but it seems he was so arrogant he was dismissed and returned to Brighton, becoming High Constable (a bit like mayor today) and being generally unpleasant, persecuting non-conformists and bossing the townspeople about. His grave at St Nicholas's leaves us in no doubt just how much this arrogant man is owed by his nation from his one action in 1651 that saved a royal family. It's a shame he did it for

THE

GRAND HOTEL,

BRIGHTON,

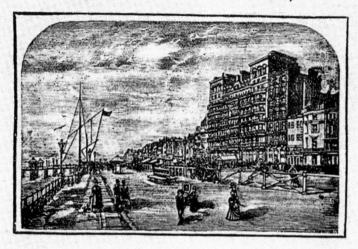

IS situated in the KING'S ROAD, facing the Sea, near the West Pier, South aspect, sheltered from the North and East Winds.

Grand Entrance Hall. Suites of Rooms. Magnificent Coffee, Drawing, Reading and Smoking Rooms *facing the Sea*. Elegant Table d'Hôte Room, also Billiard Room.

High-class Cuisine and Wines. Outside Fire Escapes. Electric Light throughout. Lift for Visitors. Hot and Cold Sea Water, Swimming and other Baths.

Some of the leading Members of the British Medical Association, when staying in the Hotel, certified as to its excellent Sanitary Arrangements.

—— Telegraphic Address: 'GRAND, BRIGHTON.' ——

TERMS 'EN PENSION' FROM 10/6 PER DIEM.

For a period of not less than three days, notice being given on arrival.

Tariff and Full Particulars on application to Mr. A. D. HOOK, Manager.

An early advert for the Grand Hotel.

The Old Ship's sign pointing to its once-hugely important assembly room.

money and not as a selfless or dutiful notion, otherwise he would be one of Brighton's great heroes. His ship certainly was a Brighton hero though, the *Surprise* lasted for at least 140 years – it was reconditioned by the Navy and was still in service until 1791. An arch from this 'Old Ship' was in the stable yard of the Old Ship for many years and is now still in Brighton Museum.

DID YOU KNOW?

Errol Flynn, a Hollywood superstar of the early twentieth century, was known for his dynamic adventures and rescues. Unfortunately he wasn't there to rescue his mother, who met the unusual death in Woodingdean in 1962 after being run over by an Isetta bubble car, the same car that was actually built in the city in one of our rare car factories. The factory is commemorated today by the road name, Isetta Square, but no memorial exists for the demise of the mum of a Hollywood heartthrob.

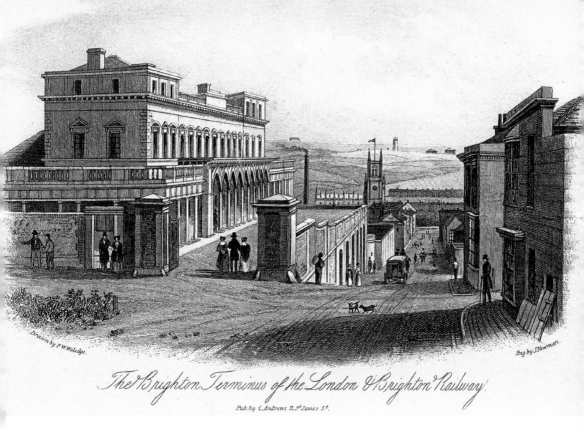

The Brighton Terminus of the London & Brighton Railway.

Above: Brighton Station hides a secret underground road.

Below: Brighton Station today.

So, due to Tettersall, Royalists everywhere have Brighton to thank as the town who without which we may not have the royal family today. In 1651, with Charles I executed and Oliver Cromwell controlling the country, the man who would go on to be Charles II was on the run from Cromwell's forces after losing the Battle of Gloucester. He had fled south-east and ended up in an inn in West Street in Brighton, which in the 1650s was the most westerly street on the edge of town, with only fields to the west of it. You can still trace Charles's route today into Brighton on any OS map, if you look for the 'Monarch's Way' route. The landlord of the inn, now believed to be where the Travelodge hotel is, recognised the future king but kept quiet, but the captain of the local vessel *Surprise*, Nicholas Tattersell, decided to charge the fugitive Charles more when he recognised him to take him to France. So George IV wasn't the first monarch to put money into Brighton!

The Old Ship Hotel, as it is now known, has continued to expand and improve. It has been a courthouse and even a post office before the town hall existed. It was also involved in movement of the heritage kind as the location where the idea of a veteran car club behind Brighton's annual Veteran Car Run was first mooted. Talking of movement, the Old Ship has itself moved, starting off life facing west in Ship Street, expanding southwards by the 1760s to face the sea and since then expanding east to reach its current size in 1939 with its eastern annexe.

Moving to movement by rail, Brighton's wonderful Victorian railway station holds a number of secrets. The current location of Brighton's main station, imaginatively called 'Brighton Station' (but originally 'Brighton Central Station') was one of five choices. One was where Park Crescent is today, and another would have been at the north of Brunswick Town. Its current hilltop location on top of the Downs was preferred as in the days of steam travel it meant that the smoke fumes wouldn't stay down in the valleys in town, but would be blown away by the Downland air in what was a rural location in the 1840s. Being higher up had its disadvantages however, horse-drawn carriages couldn't make it up what is today the still-very-steep Trafalgar Street and so a less-steep roadway was built under the station, which is still there but well hidden. You can see it if you look down through the wooden floorboards to the east of the station and through the two large wooden doors next to the toy museum. It came up where Marks and Spencer's store their trolleys today. The plans to demolish the station in the 1970s and replace it with a hideous concrete hotel in a tower block helped rally Brighton's wonderful Regency Society, who went on to help save North Laine and countless other priceless Brighton buildings. Tours of this wonderful 1840s' building by David Mocatta are run by Jackie Marsh-Hobbs and are well worth attending.

As Brighton's railway needs expanded, Brighton became not just a place whose valleys were crossed by railways and hills were drilled through, but also a place where locomotives were built. Despite the fact that thousands of men were once employed in this industry, and Brighton was a major engine manufacturer, few clues exist today. The huge tracts of land the locomotive sheds and tracks took up are today covered by car parks, walkways and the New England Quarter. The only clues left to this major manufacturer are the recreation of a locomotive on the old bridge over Old Shoreham Road that was once part of Brighton's steam goods line heading down to the goods station, where

Above: The Metropole lobby ceiling today.

Right: The Metropole's original lobby and lounge ceiling in 1890, today hidden by the 'lost floor'.

HOTEL METROPOLE, BRIGHTON.
ENTRANCE TO THE LOUNGE FACING THE SEA

Brighton's Clarendon Centre now is. The other clue is the former clocking-in shed just up the hill from the bridge, which is currently (at time of writing) still open to look inside, as someone hasn't bothered to lock the door! Of course, trespass is not recommended, but the well-trodden steps inside this little-known building stir the imagination and you can see the hundreds of railway workers climbing these on their way to build some of the massive locomotives Brighton once so proudly built in the days when we had a large manufacturing output.

DID YOU KNOW?

Brighton's first escalators were used by delegates and exhibitors in the Metropole's exhibition halls after its 1960s' rebuild. Intriguingly, guides to the Metropole's new exhibition halls (the first in Brighton) mention 'a floor surface that is not tiring'. Just how a floor surface can be tiring unless it is constructed of glue is a mystery ...

Brighton and Hove has many links to the motor car. Not only has it been the destination of numerous 'races' to Brighton since 1896 (as celebrated in the 1953 film *Genevieve*), but it has many links to cars and the car industry. Clarendon Mansions in Hove was designed and lived in by the father of Frederick William Lanchester (1868–1946), the name behind early British car company, Lanchester. They were the first British car company to use a petrol engine and also created the first petrol-powered bus in the UK. Brighton was the destination for the country's first planned motorway, but this never reached fruition. As late as the 1960s, Brighton was assembling cars with a factory in what is now the New England Quarter. The Isetta was the name for the famous 'Bubble Car' and is celebrated today in the road name. As a mostly Regency and Victorian-built city, we do indeed struggle with the car in the twenty-first century, but need to celebrate our fantastic public transport, including one of the country's most successful bus companies in Brighton & Hove Buses. We also need to be very grateful that the 1960 'Wilson and Wormersley' Report, recommending the destruction of 500 buildings in North Laine to build a flyover from Preston Circus to Church Street, (with Preston Circus becoming a mini-spaghetti junction) was unanimously rejected by Brighton Council.

Preston Circus and the Metropole Hotel were both facing possible demolition in the second half of the twentieth century but the latter has had some eccentric visitors over the years to do with movement. One naval captain, who stayed in between voyages, had a parrot trained to recite whole poems. Another elderly lady in the first half of the twentieth century hated the movement of cars below so much she used to throw hotel furniture out of the windows at passing cars as 'they disturbed her holiday'! Back in the 1980s, Barry Manilow flounced out of the Grand in fury at the hotel and moved to the Metropole, where he had the beleaguered staff running all over town searching for the right piano for him. He was finally happy with the fifth one they brought him.

Moving from the south to the north of the city, as mentioned, Park Crescent was where Brighton Station nearly ended up being built. It was one of the five possible sites for the station muted by its planners. Built on Ireland's Pleasure Grounds and designed by Wilds and Busby, our leading architects, Park Crescent at least is a crescent unlike the identically named version they built in Worthing, where money ran out so, despite its name, it is half a crescent. Movement by the Luftwaffe led to it being bombed in 1943 but so precious was the road that the bombsite was rebuilt lovingly so that it is hard to tell the non-nineteenth-centuy century buildings unless you look closely. As with much of Brighton, planning developments nearly finished what the Luftwaffe started and the whole road was earmarked for demolition to house the Brighton Technical College that eventually ended up on the Lewes Road in Moulsecoomb. That building is today part of the University of Brighton and Park Crescent is an unusual bit of Brighton as a road with its own, almost secret shared private garden that holds private parties and joint firework displays. It also has the wonderful Park Crescent pub, one of Brighton's hidden inns that are well worth making a walk to.

As people move on, knowledge dies with them. We also lose records of how our buildings once looked when we move our buildings around and redesign them. An example of the former is that, unbelievably, we're still not entirely sure how the West Pier was built. We've lost records of how exactly the large metal pillars were screwed in by hand into the seabed – we would need machinery to repeat such a task today. The nearby Metropole once had a porte cochère – a storm entrance that presumably would be on the hotel's eastern side – whose location has been lost to posterity. As mentioned, the Metropole's grounds once had a clocktower in their gardens, which was presumably demolished when removed in 1963, or else somebody has a fantastic feature in their garden somewhere! The Metropole is also missing records of where its original Turkish baths are – it is believed they are in the boiler rooms. We've also lost the plans that our most prolific architects, Wilds and Busby, nominated for St Peter's Church and the Royal Sussex County, in competitions where they came in second place to Houses of Parliament architect, Sir Charles Barry. We know it would have looked very different from the Gothic St Peter's we have today. Brighton and Hove High School was once local landowner, MP and lord of the manor, Sir Thomas Kemp's hillside mansion and had a dome as well as lots of other elaborate features. The previous owners of Brighton Pier (as they called it), the Noble Group put the remains of the Pavilion Theatre in a warehouse after the collision of a boat into the pier, whose location is now unknown.

DID YOU KNOW?

Very apt for the place that has held a veteran car race since 1897, Brighton was so keen on its motor vehicles at one point. It even had a spin-off motoring museum from Beaulieu, set up by the late Lord Montagu that existed in the days when the Sea Life Centre was the Aquarium.

Some long-lost features of Brighton have just been rediscovered, however, so it is not all bad news. As mentioned back in the introduction to this book, the Metropole has just uncovered, with help from the author, its 'secret' extra floor, installed between the lobby and the high Victorian ceiling above on the orders of the hotel's new owner in 1959, Harold Poster. On exploring this sometimes hidden and dusty space between floors, we encountered the hotel's original glamorously decorated gold-painted ceiling decorations and also its original stained-glass windows from 1890. The Metropole would be even more amazing if it had its lobby and bar back to their full height with the original Victorian ceiling again on view. The Metropole would have the most impressive facilities of any hotel in Brighton and would be closer to how it looked when it was designed back in 1890. The Metropole is Waterhouse's only seaside building of size and the only hotel he ever built by the sea. It truly deserves not only to be listed (unbelievably it is not one of the 1,218 buildings in Brighton that are, despite its uniqueness) but such a building deserves to be seen as its architect meant us to.

The Metropole was criticised by some when it opened in 1890 for looking like Waterhouse's railway station buildings. However, moving easterly, Brighton has lost a railway station and its buildings at Kemp Town and the tunnel that trains arrived to the station through is now blocked up and largely forgotten. Much more recently, Brighton has had a little-known railway at the Marina, as one of the features of the latest phase of the construction of the new Boardwalk and Outer Harbour developments was that a narrow-gauge diesel railway was constructed along the West Breakwater to deliver sheet piles. The caring developers of the Marina decided upon this unusual course of action to minimise deliveries of the piles by road on the Marina's roads, so avoiding disruption to residents.

A white ceiling in the added 1960s' floor between the lounge and the first floor, that was once viewable from the ground floor.

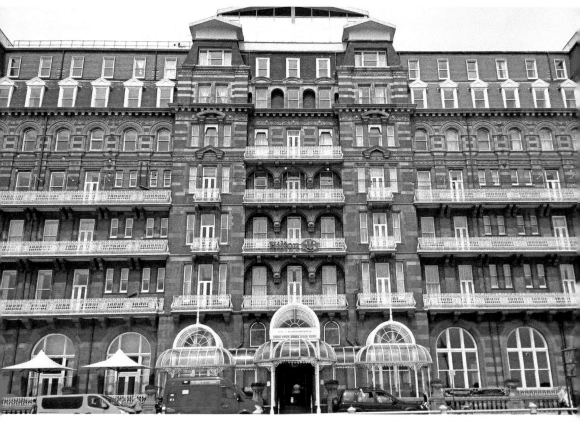

The Metropole's exterior today – the lost floor is behind the three stained-glass windows above the entrance.

6. Sticks and Stones

Names and Geology

Even established Brightonians get the names of different parts of Brighton wrong. Many get *the* Lanes and North Laine mixed up, which is to be expected, considering the similar spelling. Laines were the fields Brighton is built on and there are five of them when you add East Laine, West Laine, Hilly Laine and Little Laine. The word is an old Anglo-Saxon one meaning 'loan'. There is no South Laine – it is *the* Lanes, which is the Old Town. The Lanes are something completely different – there is only one and it is still mostly laid out in the same medieval pattern of the town that existed there until 1514, when it was burnt down by the French. The town was rebuilt on that same pattern, and even on the medieval foundations, so it is likely some of the oldest bits of Brighton are the cellars and basements of the Lanes. The town even went lower than that – the buildings were huddled together to protect from the elements and generally lower than the cliffs they were built on. 'North Laine' as a term was brought back into fashion by Brighton hero planning officer, Ken Fines (1923–2008) when the North Laine conservation area was created in the 1970s. This was after the area (that had been threatened with demolition so that a dual carriageway could be built on a flyover from Preston Circus to a car park in Church Street) became protected rather than demolished and Brighton adopted a culture of saving its historic buildings that it has kept ever since. 'Lanes' and 'Laines' may be confusing as a current term – but we only have one of our Laines, North Laine, due to Ken Fines and we should salute his memory.

Brightonians may criticise those who get local names wrong, but there have always been the odd critics of Brighton from its earliest days. One writer after the time of the Great Storm of 1703 that destroyed the lower fishing village suggested Brighthelmstone wasn't worth saving and should be abandoned to the sea. Daniel Defoe, an author who had definitely focussed on life next to the sea wrote in 1708 that the £8,000 needed to repair Brighthelmstone's sea defences was 'more than the town was worth'. The author of *Robinson Crusoe* wasn't to know just how popular the town would become with writers like himself. Another man of words, Samuel Johnson, author of the first established dictionary, famously complained during his stay on the then westerly extremes of the town in West Street that Brighthelmstone was so bare a man would struggle to find a tree to hang himself in. He was so negative about the town that many Brighthelmstonians at the time must have wanted him to try!

A century later, the Pavilion's construction led a whole range of critics to complain about the building, and to try to come up with an ever more creative range of insults. William Cobbett, an MP and writer, said it was 'like the Kremlin and a series of turnips and flower bulbs [had been] placed on top of a square box'. William Hazlitt said it was merely a 'collection of stone pumpkins and pepper boxes.' Little were they to know it is now one of the country's top visitor attractions!

West Street today, once the home of the Thrales that Johnson visited and once an overnight royal residence.

It is not the first nor the only building of its type in Brighton. The Dome and Corn Exchange, which were constructed earlier in 1805, both had the Indianesque style first, and buildings in the Pavilion grounds by the North Gate that once formed part of a much longer road also were decorated in the same style. Amon Henry Wilds, one of Brighton's three most prolific architects, also constructed a smaller 'Western Pavilion'

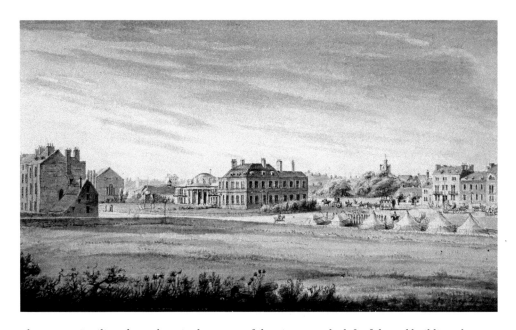

The Marine Pavilion shown here in the centre of the picture to the left of the red building, showing how Prince George's palace looked before its Indianesque rebuild. (Picture courtesy of Royal Pavilion and Museums, Brighton and Hove)

south of Western Road (now near Waitrose) in 1827–28 for himself. Nor was the Pavilion George's first residence here; he stayed at Russell House and Marlborough House as well as initially staying on the east side of the Steine, but we don't know where. Known in its first incarnation as Brighton Farmhouse, it was revamped and then became the Marine Pavilion (in only four months), and then finally the Royal Pavilion. George had firstly looked at a Chinese-style exterior, but then when he wanted an Indian-style building his building plans were delayed due to the costs of the Napoleonic Wars. It has also had several other less pleasant nicknames attached to it. What is amazing about it is that the central part of the building is still the same layout as its earlier incarnation – its Indian-style decorations were mostly added onto the existing earlier building like a mask. The Marine Pavilion was also just the original farmhouse, known as 'Brighton House' repeated to the north, with a dome in the middle – so the original farmhouse is just about still there, under the cladding of the most eccentric building in Britain.

Near to the Pavilion are the stones comprising the fountain built for Queen Victoria, which are said to be the original stones, after which the Vikings named Steine. 'Steine' is a Scandinavian word for 'stones' or 'stoney ground'. These stones are unusual for this area, and another stone with an even more mysterious past is the Goldstone today in Hove Park. The Goldstone Ground got its name from Goldstone Farm, which used to be on the site at Goldstone Bottom, and that in turn was from a 'god stone', which fortunately isn't gold or it would have been stolen long ago by strong thieves. It is incredibly valuable in

A wonderful watercolour of the Old Steine.

DID YOU KNOW?

You can find a Kitkat, a Ping and a Theobald all in the same place – if that place is a history book featuring Brighton councillors' surnames. Brighton has a Jason Kitcat and Geoffrey Theobald and once had the wonderfully named Nimrod Ping, Brighton's first openly gay councillor who was used as a yardstick to measure odd names against by Terry Wogan. The late and much lamented Councillor Ping wanted his funeral to be a joyful affair and insisted everyone wear bright clothes and sing.

a different way though, as an unusual stone identical to those at Stonehenge. It became so much of a tourist attraction that the farmer of Goldstone Farm got fed up by visitors trampling over his farm and hit it by burying it for many years! It was eventually rescued and moved across the road to Hove Park, where it can be now seen. Other stones that were definitely moved here are those from the Rockery, which is located on the western side of London Road across from Preston Park. The stones weighing 1,350 tonnes, were transported from Cheddar Gorge for its opening in 1936. The Rockery is one of Britain's biggest council-owned rock gardens and has a 'secret' lookout spot at the top with a fantastic view over the traintracks, Preston Park, manor and church. The Rockery is also reputed to be in the shape of a willow pattern.

Brighton may be well known worldwide, but there are over forty-eight Brightons around the world, not to mention Albrighton and New Brighton here in the UK. They have all also changed their names over time, but Bristol, Bricklehampton in Worcestershire and Brighthampton in Oxfordshire all started off with the same Saxon root to their names as us. You can even find a Brighton south-east of Newquay if you go on holiday to Cornwall. Those with friends in Derbyshire might want to check out Brighton Farm and anyone scouting about Scotland can scout out another Brighton farm near Fife. We are the largest Brighton worldwide unsurprisingly, with the one 6 miles south of Melbourne in Australia coming in second with over 40,000 inhabitants. Australia has three other Brightons, but the USA has the greatest number of Brightons worldwide, with twenty-seven altogether and two in New York State and Ohio each. For somewhere made famous worldwide by George IV (as the Prince Regent eventually became), it is only right that Georgetown in Guyana has a Brighton to the south-east of it. Places in Sussex wanted to create their own homages to Brighton too, with Worthing and Bognor both developing their own Steines (but Worthing spells its one 'The Steyne'). Waterloo Terrace was also copied, and Worthing even used Brighton's premier architect, Amon Henry Wilds, to build its Park Crescent. It is often said that imitation is the sincerest form of flattery, so perhaps this is great praise.

Above: Worthing Steyne – different spelling, same idea as Brighton's original grassland.

Below: Worthing's Park Crescent. Another Wilds design, but unfinished and repaired from the Second World War, unlike Brighton's version.

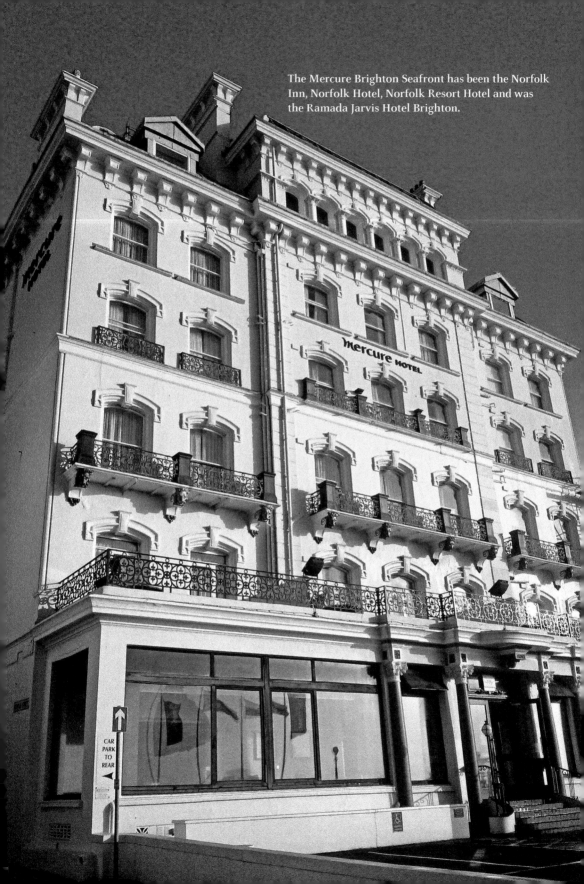

The Mercure Brighton Seafront has been the Norfolk Inn, Norfolk Hotel, Norfolk Resort Hotel and was the Ramada Jarvis Hotel Brighton.

There have often been many ready to put their praise for the city into words. Edmund Gilbert called the town 'the most attractive seaside resort in the world.' Harold Poster, owner of the Metropole, Bedford, Norfolk and West Pier in the 1960s and 1970s said once: 'Nothing is too good for Brighton.' Clifford Musgrave, Brighton author and curator of the Pavilion, called Brighton: 'A pleasure city … unique on the face of the Earth.' The author William Makepeace Thackeray sang the town's praises as a friendly place that healed the sick: 'One of the best of physicians is kind: cheerful, merry Dr Brighton', hence the name of the pub next to the Queen's Hotel, dating back to 1750 (it was called the Star and Garter before that). Horace Smith called the town both 'the queen of watering places' and the 'old ocean's bauble'. If seeing Brighton as the Capital's coastal sister is positive, then nicknames such as 'London-by-the-sea', 'London's sea-suburb' and the more bizarre 'London-super-Mare' are also affectionate descriptions. Brighton was clearly loved for its healthy air, after trains made London a sooty city, as it was called 'London's lungs'. Even fictional characters praised the town, with Lydia Bennett in Jane Austen's *Pride and Prejudice* saying how '[a] visit to Brighton comprised every possibility of earthly happiness.' The nicest thing ever written about Brighton though must be on a postcard that simply said, 'Did you ever see anything in London to equal this?' My favourite quote about Brighton is a spoken one, by Radio 2 DJ Sara Cox, who recently mused that 'Essex wishes it had Brighton'.

Should we ever need again a complex system of codes like the famous Enigma system from the Second World War, we could always do worse than using Brighton hotel names. Brighton hotels change names quicker than a pantomime dame changes her costumes! The Holiday Inn near the West Pier has been the Hilton Brighton West Pier, and before that the Bedford. The Grand started as the Grand, then the DeVere Grand but is now simply the Grand once more. The Metropole was once known by its then owner's name, Stakis and today has had 'Hilton' added as a prefix to be the Hilton Brighton Metropole, but originally was just the Hotel Metropole, in reference to the preference at the time for the French way of pronouncing hotel names. (The first two Metropoles built by the owners were in Cannes and Monte Carlo, which might also explain this.) The Mercure Brighton Seafront Hotel was originally the Norfolk Inn, then the Norfolk Hotel for many years before becoming the Norfolk Resort Hotel, and then the Ramada Jarvis Hotel Brighton. Are you keeping up? The Jury's Inn Waterfront Brighton has to be the winner for most thorough efforts with name changing as it has previously been the Waterfront Brighton, Thistle, Thistle Brighton, Brighton Thistle, The Hospitality, Hospitality Inn and then before that, the Ramada Renaissance! The Royal Albion has been the simplest, merely adding 'Royal' when it went through its era of attracting royalty into its rooms. The York Hotel also did the same, but then went on to become the Royal York Buildings when it became council offices in the 1930s, before returning as the Radisson Blu hotel and is now the YHA. Before it was the York Hotel it was Steine Houses and before that the Brighton Manor House. The aim of hotel owners seems to be to make the work of historians as hard as possible!

Brighton names can often be entertaining, or sometimes just worrying. The Marlborough Hotel near the Pavilion was once owned by Henry Witch. If you think the recent Councillor Kitcat to be the first Brightonian with an unusual name, then think

DID YOU KNOW?

Gloucester, Cumberland, and York are the names of George IV's uncles in the order that they first visited Brighton. Without their visits, George wouldn't have had relatives to stay with in the town to escape his domineering father. All of these dukes have or had streets – or even hotels named after them.

again – even before Nimrod Ping in the 1990s, back in the 1500s, the military leader tasked with avenging Brighton being burnt down by the French was Sir John Wallop. In a town always known for its large number of drinking establishments, the wealthy Anne Sober, sister of Thomas Read Kemp, must have come in for some admiration, especially if she lived up to her name. In Anne Sober's time, Brighton's chief constable can't have faced many personal allegations of police brutality if he lived up to his name as he was Sir William Gentle. A slightly more sinister Victorian Brighton policeman, however, was Inspector De'ath. In the 1910s, the West Pier's piermaster was a Mr Shirtliff, which would be a name with different connotations today, and if alive today, he would probably have a range of comments made. This would probably have also happened to the wonderfully named Count Apongi, who stayed at the Metropole in its opening year of 1890 and hopefully had a standard of hygiene not reflected in his name. A 1920s fruit merchant must have employed small workers as it was called T. Rolls. Moving into the 1970s and 1980s, Brighton and Hove had teachers with some unfortunate names. The head of history at Hove Girls' School in 1978 was a Mr Willy and in the early 1980s the computer teacher at Patcham Fawcett school was a Mr Bender. If anyone asks you if you know Paul Pieces however, he doesn't exist. Paul Pieces, along with 'Furlongs', were the names of the strips of land the lanes were divided into.

Should you want to see more glamourous names than Mr Willy's that Brighton has long forgotten, then you are spoilt for choice. From the Victorian era alone until the 1950s we were in the presence of marquesses, dukes, duchesses, kings-to-be and at least sixteen of our own royals. Moving onto the aristocracy, the Metropole's guest list for 1890 alone reads like a dinner party at Downton Abbey: it includes the Countesse of Stradbrooke, Lady Gwendoline Rous, the Honourable Charles Willoughby, Sir Jasper Carmichael, the Comtesse du Bremont, and not to forget the previously mentioned Count Appongi. Brighton's most exotically named royal visitors though must be the Maharajah of Cooch Behar, the Gaekwar of Baroda, Prince Antonie D'Orleans, the Infanta d'Espagne, Princess Alexis Dolgourouki and Prince Abrahim. All of these walked up through the Metropole's front entrance in its early days. In the 1840s, revolutions across the Continent led to Brighton becoming a home for exiled foreign royalty and leaders such as Prince Metternich, Princess Lieven and Louis-Philippe.

Brighton and Hove's place names have been lost or changed, much of which has been forgotten. The town's first and original South Street was lost when eroded by the sea. London Road was once called Queen's Road and New England and Viaduct Road were Montpelier Road West and East. Promenade Grove was a public pleasure gardens now

High society in the Winter Gardens at the Metropole from the days when the names at the hotel were often lengthy.

occupied by New Road and the Dome and Corn Exchange since 1805. It opened in 1793 for only ten years. German Place changed its name in 1914, along with other similarly named places in the county during the First World War (thankfully two German names, Sussex and Brighton, were left alone, but even our royal family changed their German surname to Windsor). Much of Russell Street/Place is today under Churchill Square, a shame for the name of the 'father of Brighton'. Chichester Place on the east side of the town on Marine Parade was originally Chichester Street, but its wealthy purchasers thought 'Street' too lowly a word to describe their superb street and so 'Place' was substituted. The most embarrassing name, had it not been changed to Spring Walk and today Church Street, would definitely be North Backside!

7. Fish and Chips

This chapter's name represents the two original groups of Brighthelmstonians – fish for fisherfolk and chips for farmers (not that there were potatoes for chips until the Elizabethan explorers brought the first ones back from the New World). Brighton's wealth in its early days was from fishing to the extent that mackerel and herring were used in Brighton instead of currency in the 1500s and 1600s. It seems it was Flemish immigrants in the thirteenth century who helped our fishing industry take off. Our fishermen were foisted elsewhere after the storms of 1700s destroyed their homes beneath the cliffs of the town. They moved from the Steine to Carlton Hill and the streets of where Churchill Square now is, and when these were demolished in the slum clearances, they moved again this time to the estates built from the 1930s. Their workplace was also similarly shifted: well-to-do visitors demanded the poor fishermen off the Steine (it was a place used for drying nets and the smell of fish might have been one reason why the east side of the Steine developed later). They were moved in the 1880s from the fishing beach (where the fishing museum now is) so it could be used for bathing – they ended up at the market in Circus Place, which eventually closed to them too. The last fishing families have since been berthed at the Marina. It's hard to believe the few boats left operating from the Marina now are the same industry that at one point in the 1580s employed eighty boats and had over 10,000 nets. It was the biggest fleet in the south, employing over 400 men who would also catch plaice, conger eels and cod. The fishermen still had a Sunday school for their children in the King's Road arches opposite what is now the Waterfront Hotel long after the fishing 'Lower Town' had been washed away by waves. Russell Street, behind the Brighton Centre and Grand today is where the poor fishing slums once were. As a place with fishing in our blood, it is only right the industry continues today and its heritage is celebrated in the fantastic fishing museum on the seafront.

The fishing community until Brighton developed as a pleasure resort outnumbered the landsmen seven to one and this numerical supremacy shows in the way they even developed their own language. So if you find yourself ever worried about Dunkirkers, contemplating how your hoggy is or whether you have been to a Dutch auction, not to mention how hot are your dees and if it you who 'has 'em?' then you are most likely a

DID YOU KNOW?

English's Oyster restaurant off of East Street is one of Brighton's longest established restaurants. In Edward VII's time he actually visited the restaurant but was told off by the two formidable sisters that ran the restaurant for daring to smoke a cigar.

long dead fisherman of Brighton. Some of the language might seem topical to Brighton's status, as having a large gay community with terms like 'bending in' once used. These were all just examples of the wonderful language of our fishermen of yesteryear. Dunkirkers were foreign, dangerous fishing or pirate sailing vessels. A hoggy or 'hogboat' was a small Brighton fishing boat that could be hauled up the stony beach easily. A 'Dutch auction' meant that fish would be sold in the Dutch style – with a high price first, then reduced, rather than the other way around. If you were successful in bidding, then the auctioneer would shout that you 'has 'em'. Dees were fires that herring were smoked upon in Carlton Row, another fishing area the other side of the Steine (once a fishermen's working area) and 'bending in' was the benediction, a blessing local priests would make for the fishermen on their boats to wish them a safe journey and return.

Not only did Brighton's fishermen give the area their own language but also a legacy of Brighton's most precious collection of streets today. The Lanes were once the fishing cottages of the earliest Brighthelmstone fisherfolk, huddled together with narrow twittens (lanes) and Paul Pieces (streets) in between where the fields in the centre of the Hempshares once were. The twittens today are packed with the shops, pubs and cafes of the Lanes and in some parts make Harry Potter's Diagon Alley seem a reality. Brighton's twittens were not just the one-time routes of fisherfolk but also provided the location for one amazing bet lost by a friend of Prince George's in 1790. The Barrymores were a wild family of Irish aristocrats that apparently caused all sorts of pranks and japes all over Brighton, once even riding a horse up the stairs of a house belonging to George IV's wife, Mrs Fitzherbert. Lord Barrymore, an athletic member of the family, made the mistake of accepting his portly friend Mr Bullock's bet that he could beat him in a 100-yard running race. Bullock's only terms were that he be given a 35-yard start and could choose the route. Barrymore acquiesced and allowed Bullock to choose. He didn't realise Bullock had selected the narrow Black Lion Lane twitten, which was of course too narrow for the Irish aristocrat to overtake his portly pal. Who ever said fat people can't win running races?

A hoggy, a small Brighton fishing boat that could be hauled up the stony beach easily.

One of the twittens in the Lanes, the Sussex word for alleyways. Here are what are believed to be central Brighton's two oldest dwellings, dating back to the 1600s.

Black Lion Lane. Brighton's most famous twitten (except for the infamous alleyway in *Quadraphenia*) and location of a famous bet.

Brighton is also the home to one of the most unusual protests over fish ever. Legendary actor Sir Laurence Olivier, who lived in the town and used the 'Brighton Belle' train to commute to London for acting roles in luxury, started a huge protest in the early 1970s when British Rail decided to stop serving his beloved kippers for breakfast. He was ultimately successful but the trains were soon cancelled anyway, so his efforts were unfortunately in vain. The pub up above the station, the Belle View was named after the trains to remember them and featured a Brighton Belle in its pub sign but is now called the 'West Hill'.

Moving on to farmers and the farming community, George IV once had a dairy for the Pavillion. He and his circle would have made awful farmers, despite his father's nickname, due to their bizarre sense of humour. Once a friend's horse was painted white and returned to him as a present. He was also highly amused by Mrs Fitzherbert's ditzy simple sister, Lady Haggerstone, who once mistook her bull for a cow and tried to milk it! Moving from the rich to the poor, the once rural village of Rottingdean was once home to the world's most stupid sheep-stealer, who gave Hangman's Stone its name too. Rottingdean, like all Sussex downland villages, has always had a number of sheep and therefore these attracted sheep rustlers. One such rustler long ago was evidently so worn out by the exertion involved in his theft of the woolly critters that he decided to take a nap at the spot that today is named after him, ensuring his stolen animals didn't escape by holding onto the rope attached to them all. Sheep may be equally stupid but en masse they can be very strong and these sheep decided to make good on their escape. As they all pulled away, working together in a example of sheep co-operation, the rope the rustler was holding onto got wrapped around his neck. The sheep's heaving led to one rustler being hanged by his stolen booty. The look on his face in the mortuary? Quite likely, sheepish.

DID YOU KNOW?

The busiest place in Brighton was once located on farmland. Churchill Square pays homage to the wartime leader who was educated in Brighton and Hove and was named so after his death in 1965. In the north-west corner of the shopping area (which was revamped in 1998), by Crown's pub is the small street called Farm Yard, which reveals what this hillside location once was.

8. Chew a Pickle

Food is important to Brightonians, as you'd expect from a place that runs 'Brighton Food Tours' as one of its local excursions, and the country's first ever Fast Food Fair held at the Metropole in the 1960s. Today, Brighton has an ethical and environmentally friendly supermarket, hiSbe, and amazing and ethical places to eat. They both can not only displace hunger but make your conscience feel much better too. The first is Silo in Upper Gardner Street but the second can also give you the opportunity to feed any religious fever you have as well as your belly. Bishop Jerome Lloyd runs the Cherubs Kitchen at the Regency Tavern, providing work for homeless people who want to get back into the catering industry or even eventually start their own food business. Before each day's cooking though, he delivers Mass as part of his role as Bishop of the Old Catholic Church in an amazing location: the tiny chapel underneath the extremely bright and colourful Regency Tavern. The Mass is even broadcast online to IT-literate followers of the church, which split in the 1800s from its Roman Catholic counterpart. You can also find another ethical eatery at the Mad Hatter pub in Kemp Town and can also eat there, happy in the knowledge that you are doing your part to help some of Brighton's many homeless gain skills and work experience.

DID YOU KNOW?

Winston Churchill, during his 1947 two-day October stay in the town where he received the Freedom of the Borough, must have been a hectic visit. He not only addressed his party and received his award but attended events and the Tory Party Conference. He was so tired that he left his wife Winnie to do most of the talking when residing at the Metropole over those two days. One of his few communications with the staff was to request that he only received the cream of the milk in the making his morning porridge for his breakfast.

With 11 million tourists every year it is no secret that visitors to Brighton get through an awful lot of food and drink – but the amount of crockery broken too is incredible. Just to give you an idea, back in the 1990s, the Grand alone served 190,000 meals in one year – 70,000 breakfasts comprising of 110,000 rashers of bacon and 30,000 slices of black pudding. For big events, the staff laid 2,000 tablecloths in one event, 800 napkins, 7,180 pieces of cutlery and poured 1,400 glasses of wine. Just imagine if Eric Pickles had decided to visit on that day too! You can't make an omelette without breaking eggs and neither

can Brighton serve up so many meals without a price. At the Grand alone, 26,000 pieces of china were broken every year – and that was without any Greek weddings!

Brighton's dining experiences haven't always had the wide range of tastes we are lucky enough to have today. French and English cuisine were the norm from the resort's earliest days with dining being a more impressive affair in the 1890s, with the Metropole's main dining room being just one example. It is still possible to dine in this beautiful dining room today at the hotel, which once fed royals and VIPs from around the world and the room is still recognisable from the picture. Banquets eighty years before that definitely weren't for the diet-conscious as one of George IV's banquets at the Pavilion had 116 courses! George's banquets were so rich and over-indulgent that they gave his younger brother, William IV, gout, and his wife Queen Adelaide got stomach pains! At least in the Second World War, when much of Brighton was turned into an RAF station, the Christmas menu looked very pleasant. A generation later, Brighton had the country's first rooftop restaurant when new owner of the Metropole built the Starlit Rooms on top of Waterhouse's wonderous waterside hotel. This was the place for the wealthy, royals and well-heeled to be seen in the 1960s and it gained Brighton's top restaurant rating from food critic Egon Ronay. The menu was the most exclusive in Brighton at the time and it survived into the 1980s, today being a function room at the Metropole called the Chartwell Suite. Not all of yesterday's food and drinks in Brighton looked that nice, however, tongue was still served as recently as the 1950s and the earliest physicians in Brighton recommended a diet of milk mixed with seawater!

The Metropole had an exquisite dining room in 1890.

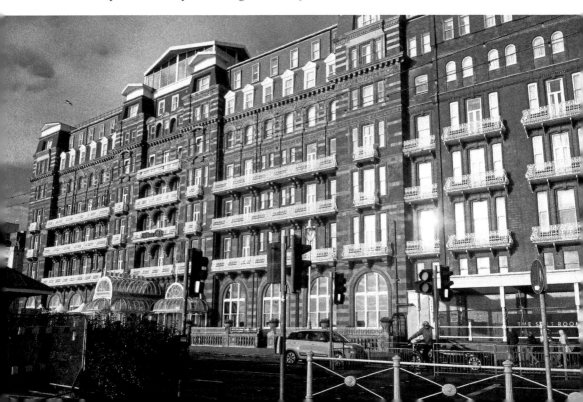

A much nicer choice of drinks are available at the Chalet Café in Preston Park, but it is a café with a surprising past. Built in 1897 by Philip Lockwood, the reason this café has a balcony around its top floor is because it was used by the park's police force to keep an eye on law and order the park, which was once the land belonging to Preston Manor. Still today, it has a cast-iron letterbox next to the door with the crest of Brighton Corporation (today Brighton Council) on it.

DID YOU KNOW?

Brighton has two graves in Woodvale Cemetery, off Lewes Road, next to each other with a breakfast theme. As unbelievable as it sounds, Bacon and Egg are resting as names on neighbouring gravestones. At least these neighbours only are half pig-themed. Worthing, 11 miles west of Brighton, had two neighbouring inns, the New Inn and Sea Hotel, which were once owned at the same time by a Mrs Hogsflesh and a Mrs Bacon. The theatre owner in the town was simultaneously a Mr Trotter. The pork-related comments must have been numerous.

9. Slap and Tickle

Sex, Violence and Comedy in Brighton

Brighton and Hove is a resort built not just on the need for people to get away and have a 'dirty weekend' but also a place which is incredibly tolerant and open-minded about all things sexual. As Brighton's version of our poet laureate, Terry Garrogan, sang in what is 'Brighton – The Anthem', 'everyone sleeps with everyone but there's nowhere to park your car.' This shows that Brightonians have other concerns rather than who is sleeping with whom. This may be as our city's creation as a holiday resort was due to the Prince of Wales escaping the court and his repressive father and coming here as a place to carry out his love life. So, George IV, as he was to become started off the tradition of the dirty weekend, although of course his stays were considerably longer than a weekend. He and Maria Fitzherbert it is now believed, had at least one illegitimate child who may have been adopted by friends of theirs. William IV, George's brother who followed him onto the throne, also loved Brighton and was also well known for his affairs.

Sex in this city of course, wasn't just confined to the Pavilion where the Royals stayed. George would take trips to a long-demolished tower in what is Moulsecoombe today for his amorous excursions. To accomplish this journey, he would have had to travel up Lewes Road. The road today and its surrounding areas is many things to many people. It has one of our best but so hard-to-find pubs, The Bugle, that it is almost a secret, several of our parks, our oldest non-religious house just off it (in Moulsecoomb), the fastest road into Brighton, the heart of our bus network and is our academic corridor. It is where we work, house many students, shop and cremate our dead. It even has an elephant buried just off it (honestly!). It also had a railway viaduct running across where Vogue Gyratory is. This viaduct, or rather the shady dealings underneath it were not only featured in the heavily violent Brighton Rock, but it gave its name eventually to a place of sexual voyeurism. This came about as the road junction gave its name to a cinema which later became a porn film and striptease club, probably the only time a road junction shared its name with such an establishment in Britain. Unless there is an intersection somewhere named after 'Spearmint Rhino' of course.

Sex and violence are often lumped together in literature and certainly so in many books about Brighton, as demonstrated by the most famous book about the city, *Brighton Rock* by Graham Greene, and the book by Patrick Hamilton that Greene advocated as even better than his own, *The West Pier*. There is no bigger example of violence than wartime, and Brighton has many wartime secrets. For a detailed exploration of Brighton's First World War experiences, Douglas d'Enno's *Brighton in the Great War* is a great read. War wasn't always needed for violent accidents to happen however. George's first ever visit in 1783 to stay with his uncle was celebrated with a royal salute from the town's gun battery, but it led to a violent injury and death of a local soldier. One of the guns misfired,

THE DOME , BRIGHTON .

The Dome and Corn Exchange in their role as Great War hospital for wounded Indian soldiers.

blasting the body of the artillery soldier that had fired the cannon down onto the beach. His hand was blown clear from his body into the sea and was never found. Strangely, another similar salute for George's baby sister Amelia a year earlier also led to another gunner also losing a hand, but fortunately that soldier survived.

Sussex soldiers across the county served their country loyally later on in two world wars, at home as well as overseas. There was one battle in the First World War where their efforts made life easier for the rest of the army at the Somme and yet their part in this battle is still virtually unknown today, despite its centenary occuring in 2016. Most Brightonians joined up to serve in the Royal Sussex Regiment and local battalions were known as 'The South Downs'. Their mascot was Peter, the regiment's lamb. The nickname for these soldiers therefore was 'Lowther's Lambs', after their commander, Colonel Lowther, and also a reference to their South Downs name. On the day before the horrific Battle of the Somme on 1 July, these Sussex Regiments, highly packed with Brightonians, were given the task of creating a diversionary attack. The idea was that the Germans would think the attack would be where the Sussex lads were, north of the real attack. The South Downs were based at Richebourg, north of the Somme valley in a trench section nicknamed 'Boars Head' as the trenches stuck out here in the shape of a boar's head. This land was even harder to advance across than the Somme as battles had been fought here already. The Germans even expected a raid and so were ready, sending messages across no man's land saying 'When are you coming Tommy?' Casualties on the attack at Boars' Head on 30 June 1916 were even heavier understandably than the Somme, which started a day later, and Brighton boys took the heaviest toll. The battle was known as 'the day

Sussex died' and the sacrifice of these men meant that some enemy soldiers were held up further north and unable to attack fellow soldiers elsewhere. Their gallant efforts should make Brightonians proud and the Battle of Boars Head should be better known among the people of Sussex.

British soldiers were not the only soldiers fighting the Germans in the trenches, of course. Over a million Indian soldiers enlisted to rally behind the 'mother country'. Brighton became a place known for its medical know-how once again, but this time for treating the wounds of soldiers from India in the first two years of the war, rather than treating the wealthy with seawater cures. Injured soldiers were originally put up in the General Hospital, Dome and Pavilion, while battered British soldiers would be in what is now BHASVIC (then the Boys' Grammar School) and also later the Kitchener Hospital (now the Brighton General hospital). Less known about this time though is that a wall had to be built around the Pavilion and Dome, partly to protect the Indians from becoming a type of 'zoo' exhibit for curious Brightonians (although locals soon managed to use local double-decker buses to view the soldiers). The wall was also designed to prevent Indian soldiers visiting the local prostitutes, who were doing a roaring trade in a town full of military men of all types.

Brighton may have been full with casualties and those escaping the horrors of the Great War, but it was without a certain group of its citizens. Numerous Brighton families, including many who worked in Brighton's hospitality industry, tended to be from overseas. Before the First World War, Austro-Hungarians and Germans had been commonplace in Brighton's hotels, but once hostilities commenced they faced instant

Chris and Liz Wellwood, descendants of Frederick Wesche, meeting Metropole staff member Scott McAllister in 2015.

dismissal, internment or deportation under the British Nationality and Status of Aliens Act 1914. Some hotels advertised proudly their compliance with this rule as the advert below for a rival hotel shows. The Metropole's one-time head waiter, who, according to orbituaries, had been an employee of the hotel for two decades in 1914 was Mr Frederick Wesche, who had lived in Britain for thirty years. Despite being a long-term naturalised British citizen and three of his sons going off to fight *against* Germany, he was one of 400 German or Austrian-born Brightonians given forty-eight hours to move further north away from the coast or leave the country by the authorities or face internment. The hotel was even swifter and gave him only thirty minutes to leave. This was despite his prominent position in the city, and the fact he had founded the Brighton Branch of the Geneva Association in 1903, a hotels and restauranteurs association. Frederick Wesche opted for emigration from his home rather than internment or moving north and left for Bridgeport, USA until his death. He ended up as a prominent citizen of the city that took him in. His family ended in Canada when his daughter married a Canadian soldier and I had the pleasure in 2015, of meeting his descendent, Chris, a Second World War veteran who, along with his wife joined me for afternoon drinks at the Metropole where he presented me with a picture of his great-grandfather and of the Metropole just

Left: This advert draws attention to exactly who they refuse to employ.

Right: A portrait of Frederick Wesche before his forced emigration in 1914.

before the war. Brighton's loss was America's gain and this little-known story, with its separation, feelings of shame and disloyalty to naturalised British citizens a century ago, seems hard to understand in our more peaceful times. A symbol of the interdependent peaceful relationship that thankfully exists again between Britain and its EU neighbours is today the Metropole's General Manager is again a German man, Sascha Koechler.

Moving back in time a generation or two, and from violence back to sex, we experience (not literally, or without a time machine!) that prostitutes also feature heavily in Victorian Brighton, as you would expect for that era. Expensive, unusual and beautifully built, Wykeham Terrace next to St Nicholas's graveyard was once the home for 'penitent women' (prostitutes). Father George Wagner founded the Brighton home for penitent women in adjacent Queens Square and so great was the demand for the priest's place of penitence that Wykeham Terrace's houses became its annexe.

Not far from his son Arthur Wagner's St Bartholomew's Church (the only one of his family's constructions that is Grade I listed) we have the King and Queen pub, once, like the Pavilion, another farmhouse situated in Sussex countryside when first built. It takes its name from George III and his wife, despite the fact it has Henry VIII and Anne Boleyn adorning its 1930s' rebuild. It was the destination for an unlikely sex symbol (except to some fellow Tory MPs) who nearly missed a risqué event. This is because Margaret Thatcher turned up unannounced during the 1982 Conservative Party conference for a revue evening! Luckily, it wasn't during one of the 'Miss Miniskirt' competitions the pub also used to hold that same year or she might have been less than approving – or, even worse, asked to wear one. Either of which are not particularly pleasant potential scenarios. Other visitors the Iron Lady might have approved slightly more of would have been the soldiers, whose military barracks once existed behind the pub, but she would have needed to return to the early 1800s to do this. The soldiers were served beer from a hatchway that existed between the earlier version of the pub and the barracks. How many army bases can boast that today?

Army bases have facilities for nuclear war and so, unbelievably, does a secretive location in Portslade. Portslade is an overlooked part of Brighton and Hove, but was once bigger than Hove and the village and its ruined manor is always worth an explore, north of the Old Shoreham Road. Once known as Copperas Gap, the south end was important too as a bustling port, which is now grouped together with 'Shoreham Harbour'. The busy south part of Portslade needed its own police station, which it got in St Andrew's Road in 1908. Today this old police station is unique and certainly one of the city's biggest secrets as it was mothballed in the 1950s and still has many of its original Edwardian features – including three of the original Edwardian police cells intact at the rear. Behind these cells is something even rarer, however that not many people have ever seen. As Portslade was such a vital port (Shoreham is the nearest coastal port to London) in the 1940s it became a decontamination centre so that should the Russians use chemical or biological weapons, soldiers or civilians could be treated for the effects. As the Russians developed nuclear weapons, this bunker at the back of the police station then became a nuclear decontamination centre – one of only six in the UK. Radiation-exposed VIPs or key people would have passed through its shower room if they'd survived a nuclear blast, which still exists today. Thankfully it was never used except when the local bobbies

Rastrick's Viaduct today.

The viaduct was the target for an unusual Second World War bombing raid in 1943.

Left: Damage sustained in 1943.

Below: Attempts to repair the damage to Rastrick's viaduct.

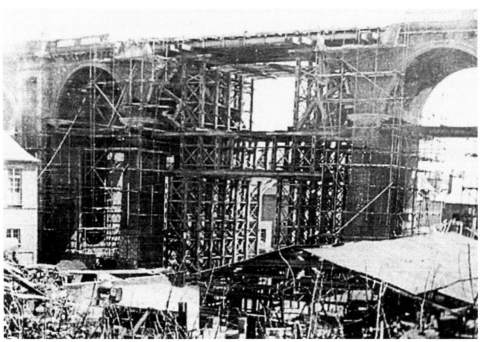

decided to help the odd drunk cool off, but Portslade still has this remarkable and rare legacy of the Cold War in a residential street today.

Brighton has a legacy from the Second World War too – a 1940s' repair to its 170-year-old railway viaduct, Rastrick's Viaduct, that spans the London Road Valley. This was involved in the strangest act of wartime violence to Brighton, which took place in 1943 when a Focke Wulf 190 launched its own version of the Dambusters raid on the Brighton to Lewes railway line at Rastrick's Viaduct. The bomb hit the bridge, but not before bouncing along Campbell Road, which faced the viaduct, smashing through two houses in Argyle Road (still without going off!) and then *finally* hitting the viaduct. Defiance to the Nazis was shown by the way a temporary railway line was soon rebuilt over the smashed railway bridge and the repaired Grade II-listed viaduct has since survived now into its 170th anniversary year. The Nazi bombing raids in the Second World War aimed to destroy the town's morale, but they definitely didn't deter one moggy in 1943 from a much-enjoyed kip.

The people in the Second World War most involved in secrets are, of course, spies and Brighton had no less than four of the experts in espionage born in the town: Lt Jacqueline Nearne MBE, Capt. Michael Trotobas, Capt. Ronald Taylor and Capt. Edward Zeff MBE. Nearne was one of Winston Churchill's secret Special Operations Executive (SOE) and her role was to support resistance fighters behind enemy lines. So successful were her endeavours that she was awarded the Croix de Guerre by France on top of her MBE from her own country. Captains Trotobas and Zeff also served in enemy-occupied France working with the resistance, with Trotobas losing his life in action. Capt. Taylor served further afield with resistance fighters in Italy.

Wars breed secrets and for a place that avoided medieval battles (like at Lewes in 1264), most of the Civil War and only saw invading armies from Roman to Norman times, Brighton has a number of secrets from past conflicts abroad. We have a number of servicemen buried here – and at least one servicewoman! Our cemeteries in Bear Road include a number of First World War and Second World War dead, or those who died after the war but had served, including this author's own great-grandfather. Some of these are from air raids, accidents or where servicemen had returned home but died from injuries. However, there are some graves you would not expect. Bear Road Cemetery has a number of German air force graves from the Second World War and valiant Indian soldiers who died of injuries while being treated in Brighton hospitals had their cremated ashes buried up on the Downs near Patcham at the Chatri memorial. This is well worth the walk today from Braepool or the Jack-and-Jill windmills and provides an amazing view of Brighton. It is today a registered war grave but was disrespectfully used for target practice during the Second World War. St Nicholas's graveyard (cemeteries are different to graveyards in that they aren't attached to a church) has the grave of the amazing Phoebe Hessell, who disguised herself as a male soldier to serve with the man she loved. She said for years she claimed to have served with the 5th Foot Regiment and to have revealed her gender eventually to the general's wife when she was injured, both of which tales were later questionable when historical research was undertaken into the timeline of the regiment. The 5th Foot's descendents today, the Northumberlands, still refuse to believe this however, and in 1970 they restored her grave in St Nicholas's graveyard.

10. Words and Pictures

It isn't always widely known that Brighton hasn't always been called Brighton and it was named by German invaders (as was Sussex). The earliest name for the city was given by Saxon invaders who came to England in the 470s. The name 'Sussex' itself comes from the 'South Seaxe' – the kingdom of the South Saxons, so we in Sussex once had a king and were a colony founded by German invaders! (Say 'South Sax' over and over and listen to which county name you end up saying). Brighton has had a number of names over the years, with its current title first appearing only in the 1660s and being adopted officially in 1810. Before that we were the wordy Brighthelmston(e), which itself evolved over time from Bristelmestune, Brithampton and Beorthelmstone. So it appears a Saxon leader called Beorthelm established a 'tun' or 'homestead' early on in Anglo-Saxon times. Later Saxon settlements locally were named after the people or children of their leader, such as Ashington or Washington. Had this been the case we might be Brightington today!

From warlords to wives, albeit one whose marriage was kept quiet at the time, Maria Fitzherbert, George IV's secret wife, left us behind Steine House and a royal love story. She is also commemorated in Mrs Fitzherbert's pub in New Road, which used to serve Jenga-style chips! She also influenced another Brighton pub and an addition of words to our local language. The north side of Mrs Fitzherbert's house's faces what is now the rear of the Royal Pavilion Tavern, which one owner, Edward Savage, decided to develop by opening a 'Gin Palace' at the rear, with a sign stating this wording. Mrs F took offence to the sign and apparently made the owner change it, so he put up a sign advertising 'Shades', either due to

Steine House and alleyway, the location where the Sussex term 'shades' was created.

the shady nature of the passageway between the buildings, or to the characters who would be frequenting a gin palace. Mrs F was presumably happy, and the word took off – a 'Shades' Bar became Sussex lingo for a bar at the rear of a public house where the shadier customers would go, with 'Oyster Shades' being bars of this ilk that also had prostitutes available (oyster being Victorian slang for female genitalia). Nearby Worthing even had the 'Nelson Shades' – a bar at the back of the Nelson Inn, above which was for a while Worthing's first 'town hall'.

A bumper number of books and poems have been set in Brighton, or inspired by the city – from Jane Austen to Peter James. Regency Square, when called Belle Vue Fields, was used for military encampments, and Jane Austen referred to the area and even alluded to the marriageability of Brighton men in *Pride and Prejudice*. Charles Dickens, son of the author, stayed in Brighton in 1891, decades after his father's death, to rest after a series of lectures. Dickens Jnr preferred the Metropole, whereas his father famously stayed in the Bedford, which burned down seventy years later in the 1960s. Dickens Snr also stayed at the Old Ship in February 1841, which was the year in which *The Old Curiosity Shop* and *Barnaby Rudge* were published. He even mentioned a Brighton ale, Brighton Tipper, in *Martin Chuzzlewit*. He gave readings of his novels from the Old Ship and Royal York hotel (the YHA today) and at the town hall. George Osborne has also stayed at the Old Ship, not the Conservative Chancellor of the Exchequer, but a fictional character in William Makepeace Thackeray's novel *Vanity Fair* (1847–48). Thackeray was positive about Brighton, which might have been due to his pleasant stay at the Old Ship, where he wrote parts of *Vanity Fair*, and the Royal York. Poets Tennyson and Wordsworth also stayed at the Old Ship, and author and Prime Minister Benjamin Disraeli graced the Royal York Hotel with his presence.

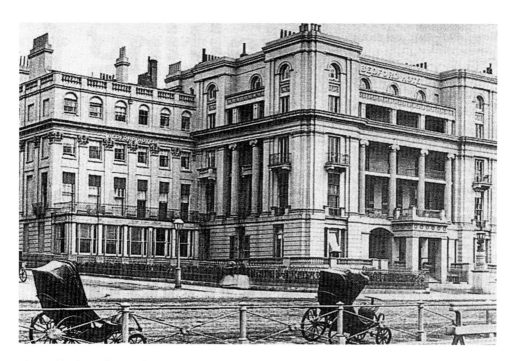

The Bedford Hotel, a much lamented Regency-style hotel replaced by a 1960s' eyesore.

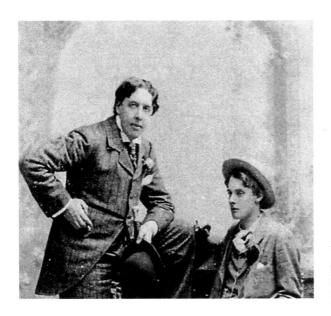

Wilde and Bosie. Picture courtesy of Antony Edmonds from his book *Oscar Wilde's Scandalous Summer* (2015).

Oscar Wilde stayed first at the Royal Albion and then at the Metropole from 4–7 July 1894 with Lord Alfred ('Bosie') Douglas after leaving nearby Worthing where he wrote his most famous play, *The Importance of Being Earnest*. While staying, he and Bosie crashed a horse and carriage into railings in Regency Square and fled from the Metropole without paying their bill. However, Brighton's most famous author must be Graham Greene due to the worldwide fame of *Brighton Rock*, but it is lesser known that he wrote also about the Cricketers pub in two books, *Brighton Rock* and *Travels With My Aunt*, which aptly has its own 'Greene Room' today. He also stayed at the Royal Albion and the Metropole, both of which being places he wrote some of his work. Greene disguised either the Bedford or the Metropole as the 'Cosmopolitan' in *Brighton Rock*, which was where he based his gang leader, Mr Colleoni.

Peter James is Brighton's most successful boy-done-good and wordsmith today, with 17 million copies of his books sold around the world. Originally a writer of (usually supernatural) thrillers in the vein of James Herbert, he has since focussed mostly on the tales of Roy Grace, a fictional Brighton detective superintendent. Grace is based on James's long-term friend, now-retired Detective Superintendent Dave Gaylor of Brighton police, and many other real police and other public sector heroes are not only the basis for characters in the book, but actually appear as themselves in the book. Even readers may not know the level of dedication that Peter puts into his work. In an interview I undertook with him for my 'Brilliant Brighton' series for Brighton's *Argus* he revealed the following:

I regularly spend time out with the police and gain a huge amount of inspiration from things I see over and hear over that time. I spend an average one day a week with the police, either in a patrol car, or an office, or at a crime scene, or on a raid, or with their Intelligence or forensic or search units – there are so many different parts to their work. I even have my own police car in Brighton that my publishers, Macmillan, and I donated to them.

Peter also revealed some things about himself that perhaps might not be secrets, but he admitted even most of his readers wouldn't know. They were:

1) He was once Orson Welles' house cleaner
2) His mother was glove-maker to the Queen
3) He loves motor racing, and owns a number historic cars that he races
4) He was selected to train for the British Olympic Ski Team at the age of fifteen
5) He once broke the Under-Sixteens British 100 yards sprinting record

Peter frequently says how Brighton inspires him, but it doesn't just inspire literary compositions – it also inspires musical ones too. A stay in Brighton inspired Noel Gallagher to write an Oasis song, 'The Girl in the Dirty Shirt'. He wrote one of the songs on the 1997 album 'Be Here Now' before a night out in Brighton. The song was inspired by his stay with his then girlfriend, Meg, as they were getting ready in their room at the Grand Hotel to go out after a successful show in the town at the Brighton Centre back in 1994. Noel watched his girlfriend (whom he later married) get ready but as she could find no clean clothes she had to iron a dirty shirt. It's nice to know that even the rich and famous have to do ironing too.

Brighton's media try and avoid people's dirty laundry, with all three newspapers and the numerous publications having a reputation for honourable journalism rather than printing scandalous words about celebrities and garrulous gossip-mongering. Brighton and Hove's media is booming as not many cities could boast two periodical newspapers. The strangest newspaper publishing location must be the Pepper Pot in Queen's Park Road, which was so small it was later used as a public toilet!

Brighton has perhaps not hidden words, but a range of letters. Over the front porch of the Royal Pavilion is 'AD MDCCLXXXIV', roman numerals ordered to be written by the prince who would later have the Pavilion built, but have caused confusion as they spell out '1784', years before the current Indianesque-style Pavilion was built by Nash. They are from the year before the prince bought and had pulled down most of the original farmhouse on the Steine to build his first 'Marine Pavilion' to designs by Henry Holland. The date is meant to show the year the prince first resided in Brighton, not just visited. That was the year before, when he stayed with his uncle. There are also messages hidden in the walls for pubgoers in both the Basketmakers and the Prestonville pubs. The Metropole has 'HM' in its brickwork and originally had it printed in gold in every chair when it opened in 1890. The Mercure Seafront Hotel has 'NH' repeatedly built into its wonderful metal banisters of its graceful staircase, which seems bizarre until you know it was called the 'Norfolk Hotel' when it opened in 1866. It is lesser known today that William IV also used the Pavilion as his summer residence after his brother's death in 1830. You can still see his initials on the lampposts around the gardens of the Pavilion should you want to see another memorial to him today. Quite apt for a leading light in Brighton's history.

Pictures in Brighton pub signs tell us long-forgotten messages. The Black Lion in the pub sign on the pub on the corner of Black Lion Lane originates from Flanders. This is where the Black Lion's (and possibly Brighton's) first brewer, also one of Brighton's most

Above: The Mercure Brighton Seafront – location of a series of mysterious letters in its ironwork, unless you know its history.

Below: The Royal Pavilion, location of the letters AD MDCCLXXXIV, here showing how Fast Street used to continue through the Pavilion's gardens.

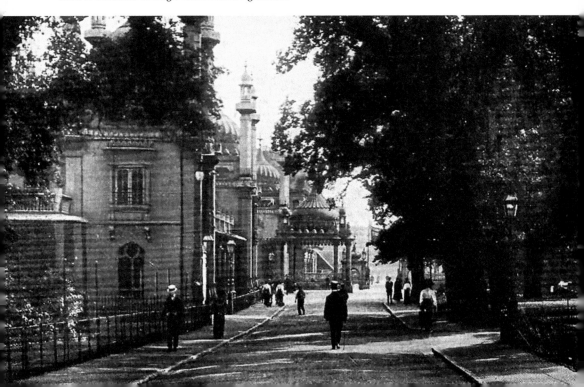

famous early residents, Deryk Carver also originally came from. Carver was a Flemish refugee and, like the French Huguenots, escaped the persecution of Protestants in France and the Netherlands at that time. He is believed to have fled to Brighthelmstone around 1546, a year before Henry VIII's death. Two of the Tudor monarchs welcomed fellow Protestants to England and Carver was unlucky enough to arrive at the time of one that did and stay for the reign of one that didn't – Mary I who, as every schoolchild hopefully knows, was referred to as 'Bloody Mary'. This was due to her order that Protestants who held on to their faith and refused to convert to her Catholic beliefs would be brutally executed, and in Carver's case, burnt to death.

Carver escaped likely death in what is now Belgium only to face it north-east of Brighton in Lewes, along with sixteen other protestants, leaving his five children without a father. It is believed Carver was burnt outside the Star Inn in the High Street in Lewes, but unlike the other sixteen was burnt to death in a barrel to mock his 'lowly profession'. This is bizarre as a brewer was a profession held in high esteem in Tudor times, especially as Flemish brewers brought the addition of hops to make British beer taste the way it still does today.

Despite his Lewes execution site, Carver's ghost is reputed to haunt the cellar of the Black Lion pub, a 1970s' recreation of the brewery Carver started up the year of his arrival to Brighton, which was demolished in 1968. Some historians argue that the brewery may even have been further south in Middle Street or even in a different location, which suggests the 'ghostly noises and goings-on' the *Argus* reported in the pub in 2006 may

The Star Inn, Lewes. It was outside here that Brighton brewer, Deryk Carver, was burnt to death.

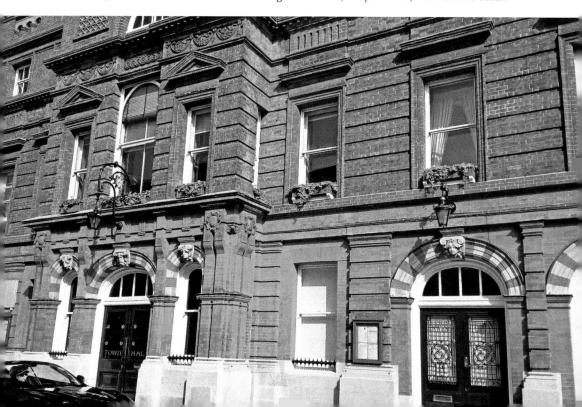

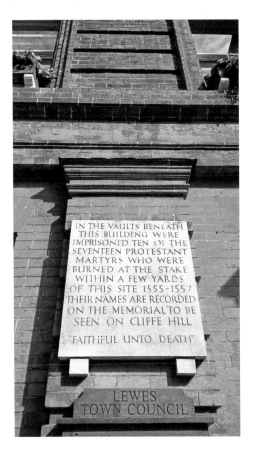

IN THE VAULTS BENEATH
THIS BUILDING WERE
IMPRISONED TEN OF THE
SEVENTEEN PROTESTANT
MARTYRS WHO WERE
BURNED AT THE STAKE
WITHIN A FEW YARDS
OF THIS SITE 1555-1557
THEIR NAMES ARE RECORDED
ON THE MEMORIAL TO BE
SEEN ON CLIFFE HILL

"FAITHFUL UNTO DEATH"

LEWES
TOWN COUNCIL

Plaque commemorating the death of Carver and sixteen other Protestant martyrs.

not be of Carver's doing. Arguments by the ghost-believing community that it could be the ghost of Carver include the fact that the brewery's original building materials were used to create the new pub, that spirits can move location to continue haunting and most of all that the level of supernatural sounds and activity increase around the anniversary of Carver's 'deathday' on 22 July. Whether or not Carver still haunts the pub that is a homage to his place of birth and the brewery he founded, he has left a legacy that demonstrates that not only is Brighton a place built by refugees and immigrants, but that their contribution to our city has always been a great one.

The leading light in the development of pictures, in terms of the moving ones of cinema and colour photography, was a Brighton citizen at No. 20B Middle Street, William Freize-Greene. Although he had already gained the patent for the first moving picture camera by the time he moved to Brighton in 1898, he did conduct several of his key experiments in this street, which helped him make cinema a reality for the masses in the twentieth century. His workshop was a shed at the rear of his garden, which shows that men can accomplish great things in sheds!

Without Frieze-Green, we wouldn't have had our wide number of cinemas that Brighton once boasted and the decent number still today. One of our most famous today, and one of the oldest in the world is the Duke of York's Cinema at Preston Circus. It gained its

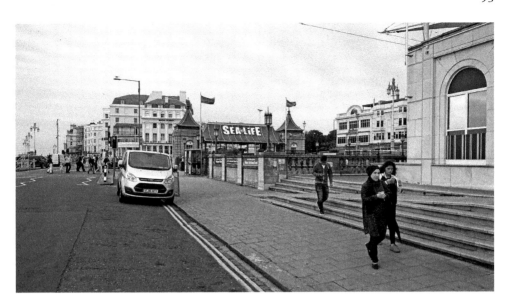

The Sea Life Centre (or the Aquarium) was once temporarily used as a cinema.

name due to a past manager, Mrs Violet Melnotte-Wyatt, who owned the lease and was also the manager of the theatre in London with the same name. It had seating for 800 when built in 1910 and was incredibly luxurious for its time. It is the oldest purpose-built cinema in Brighton (there was one older cinema in Brighton, but was converted and no longer exists) and one of the oldest in the country. It had a predictable stage in the 1970s as a bingo hall and a less-predictable stage as a wrestling hall but now is a valued part of Brighton's festival and filmgoers' lives once more, another part of Brighton it would be unimaginable not to have. It is a wonderfully eccentric building, made even more eccentric by its famous stripy legs dangling from the roof.

Brighton had many other cinemas, some of which were as impressive or as quirky as the Duke Of York's. Boots, by the Clock Tower (soon to be John Lewis), was once one the massive Regency Cinema and the Burger King in North Street was once one, as you can tell if you eat in its mock-up auditorium inside. Western Road had a small cinema but most surprising is that home of Heart radio station (Southern FM/Southern Sound) in Franklin Road, Portslade, was once the Rothbury Cinema. That was just the start, however. Brighton has lost these cinemas since the early days of the silver screen: the Grand Concert Hall and Picture Palace was in West Street; the Novelty/ Empire Novelty Theatre was also in West Street; going east we had the Imperial/St James' cinema in St James' Street; the Royal Tierney existed in Edward Street; the People's Picture Palace was in Lewes Road; over in Hove there was the Hove Cinematograph Theatre in Western Road; and coming back towards Brighton where the Melrose restaurant now stands was the Pandora Gallery. Then there were the buildings that had temporary use as cinemas: Hove Town Hall, the Young Men's Institute, the Palace Pier Theatre, the Aquarium (the Sea Life Centre since 1991), the Dome, Hippodrome and the Salvation Army's Congress

Hall. People have not only watched Brighton appear in many films, but watched many films in Brighton too.

My favourite part of Brighton that is a little-known secret, of all of the ones we've covered in this book, it is the last secret spot in Brighton and are the words written on the grave of Tatters, a dog buried in Preston Manor cemetery. Tatters was either held in very low regard or his owners had an impish sense of humour. Either way, this gravestone sums up the great sense of humour Brightonians have had down the centuries. Tatters' gravestone perhaps also explains why people of this city have achieved great things but why we've never held Crufts here. The gravestone is simply engraved with the following:

Here lies Tatters. Not that it matters.

Brighton today matters to an awfully large number of people worldwide, but that doesn't mean this wonderful place, situated between the Downs and the sea, won't continue to keep many fascinating secrets in the future.

Preston Manor, home to the pet grave with an unusual inscription.

Acknowledgements

Thanks again to Alan Murphy and the team at Amberley for commissioning this book. Peter James and his team were indeed helpful in allowing me to ask him questions last year, even though he was busy getting married. Mike Gilson and the team at the *Argus* as always generously allowed me access to their archives and were encouraging as always. Anne Martin, General Manager of Brighton Palace Pier, kindly allowed me the wonderful experience of being writer-in-residence in a booth on the pier to write this book. This meant I had the best source of inspiration possible for a writer while researching and producing this book – the people of and visitors to Brighton itself. Gratitude as always to Kevin at the Royal Pavilion and Museums, Brighton and Hove for kind permission to use their images as well as the suggestions and permission from the Brighton Society of Print Collectors. They also kindly granted use of their images.

A special thank you and well done to Maddy at the Youth University at Davison School, Worthing, who contributed the research on unidentified floating objects (on page 18) during one of our workshops on junior journalism.

About the Author

Kevin Newman, is a Brighton-born author, historian, broadcaster, tour guide around the city and history teacher. He writes GCSE History textbooks for Oxford University Press, scripts for educational films and has written for the Brighton and Hove *Independent* and *Argus* newspapers. His books *Brighton and Hove in 50 Buildings* and *Lewes Pubs* have both been published by Amberley and his next book for Amberley will be *50 Gems of Sussex*. He is married with two sons, one of which can be spotted in one of the photographs in this books.

Selective Further Reading

d'Enno, Douglas, *Brighton and Hove in the Great War* (Pen and Sword, 2016)

d'Enno, Douglas, *Sussex Railway Stations Through Time* (Stroud: Amberley, 2016)

Edmonds, Antony, *Oscar Wilde's Scandalous Summer* (Stroud: Amberley, 2015)

Newman, Kevin, *Brighton & Hove in 50 Buildings* (Stroud: Amberley, 2016)

Newman, Kevin, 'Brilliant Brighton' (*The Argus*)

All-Inclusive History Tours of Brighton

For 'Secret Brighton' talks and walking or motorised tours of the city, please call All-Inclusive History on 07504 863867 or email allinclusivehistory.org. Other tours are available including 'Lost Brighton', 'Royal Brighton', 'Business Brighton' and 'Brighton and Hove in 50 Buildings'. All-Inclusive History also run a range of Sussex and Brighton-based events for businesses, organisations and schools.

Those who have attended Kevin's tours have included Sotherby's School of Art, the Brighton and Hove Chamber of Commerce, Radio 4, members of the Labour and Liberal Democrats conferences, numerous schools and his own children (under duress).